RM

FORM

English-language edition for the United States, its territories
and dependencies, and Canada published 2004 by
Barron's Educational Series, Inc.
© Copyright of the English edition 2004 by
Barron's Educational Series, Inc.
Original title of the book in Spanish: *Forma*

Copyright © 2003 by Parramón Ediciones, S.A.—World Rights
Copyright © 2003 authorized reproductions, VEGAP,
Barcelona, Spain
Published by Parramón Ediciones, S.A., Barcelona, Spain

All inquiries should be addressed to:
Barron's Educational Series, Inc.
250 Wireless Boulevard
Hauppauge, NY 11788
http://www.barronseduc.com

International Standard Book Number 0-7641-5779-5

Library of Congress Catalog Card Number 2004101691

Editor: **Fernanda Canal**
Editorial Assistant/Illustration Archivist: **Carmen Ramos**
Text: **Josep Asunción, Gemma Guasch**
Exercises: **Josep Asunción, Gemma Guasch,
Esther Olivé de Puig, David Sanmiguel**
Graphic Design: **Toni Inglès**
Photography: **Studio of Nos & Soto**
Layout: **Toni Inglès**

Printed in Spain
9 8 7 6 5 4 3 2 1

FORM

CREATIVE PAINTING

Gemma Guasch
Josep Asunción

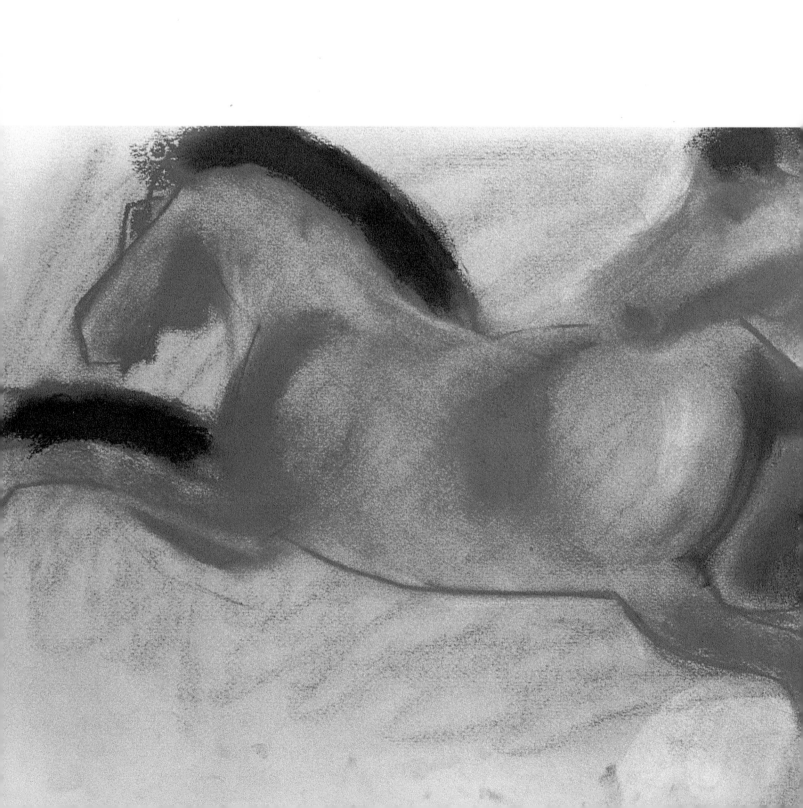

Contents

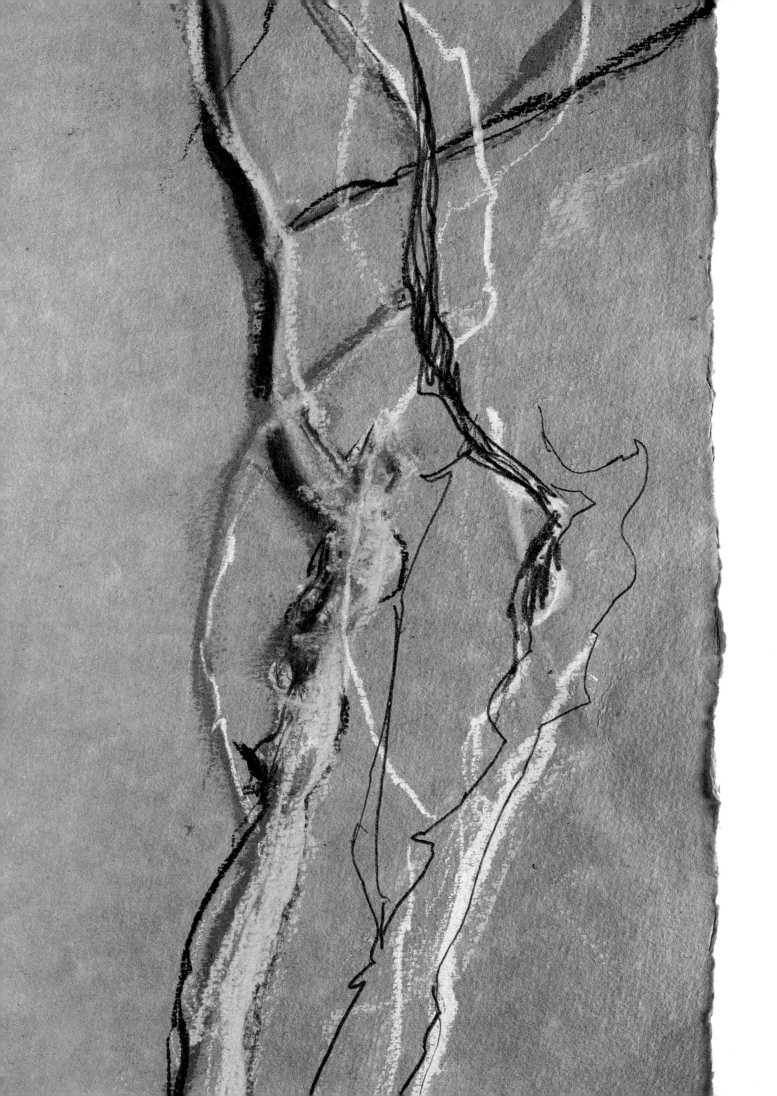

Introduction

There is no art without creation. Therefore creativity is an indispensable technique that every painter must develop. Creativity involves risk and taking chances. Creativity is throwing oneself into the adventure, pursuing uniqueness and innovation, searching for the personal response. But it does no good to jump into the sea if we do not know how to swim; the experience will not last very long. Learning to paint is learning to function within the medium of painting, its visual language, just like learning to swim is learning to function in the water. This book throws us into the water while providing us with help, since it stimulates the development of creativity, and at the same time it introduces us to the medium and its artistic language.

Verbal language consists of an alphabet and syntax; words and silences take on meaning in each phrase, and each phrase in the entirety of the text. It is the same in a painting: artistic language is composed of elements that take on meaning in a composition, like in verbal language. The alphabet of painting is made up of color, form, space, and line. The first three elements are very much related to the image and the last with the physicality of the painting. If we compare it to verbal language again, the color, form, and space are the words, the pauses, the expressions or phrases, and the line would be the tone of voice, the speed, and emotional charge of the speaker.

It would be absurd to attempt to study each one of these four elements isolating them completely from the others, since the four of them are interrelated in the same way that words, silences, and intonation are in speech. But it is possible to focus attention on each one of them, to really learn how visual language works and to respond creatively using this language. In this book we are going to focus our attention on one of them: form. Following an introduction explaining the theory of form in painting, there are fifteen creative approaches grouped thematically by painting genre so the reader can experiment creatively with form, in search of a personal language.

Gemma Guasch and Josep Asunción

Gemma Guasch and Josep Asunción are visual artists who combine artistic creation with the teaching of painting. Both have degrees in fine arts from the University of Barcelona, and each of them has had many exhibits in Spain, Italy, and Germany. Since 1995 they have worked together on projects under the name of Creart, a cultural association that experiments with collective artistic creation. Each one of the approaches in this book is endorsed by their extensive experience as professors in the Escuela de Artes y Oficios in the city of Barcelona, where they direct the painting studios.

One paints with his head and not with his hands.

Michelangelo,
Letter to Monsignor Aliotti,
1542.

Form in

"For me a form is never something abstract;
it is always a sign of something. It is
always a man, a bird, or something else.
For me, painting is never the search for
form for the sake of form."
Joan Miró
Interview with James Jonson Sweeney
for *Partisan Review*, 1948.

Visual Language

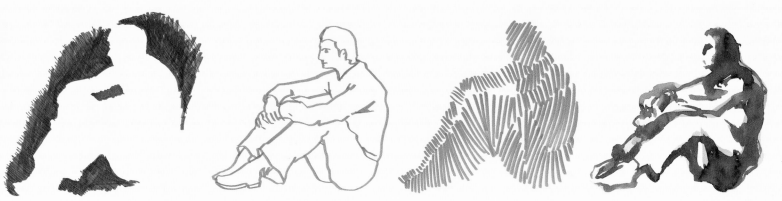

Form and Visual Perception

When we speak of form, we refer to two realities: on one hand, the external appearance of objects (their "body") and, on the other, the mental model that we have of them (their "soul"). Some languages have different words for both concepts, others just one. In any case, although both realities are very different, they always go together, like the two sides of a coin.

This connection between physical or perceptive form (body) and general or conceptual form (soul) becomes obvious during the act of perceiving. Perception is not a passive phenomenon, but an active process: the eyes are only receptors of stimuli, but the brain, the true protagonist of perception, collects these stimuli and analyzes them, synthesizes them, and relates them to models acquired in previous experiences.

In visual information, form must be isolated and recognizable by its structure (by its silhouette, skeletal structure, outline, or volume), so that the spectator can identify it by associating it with his or her mental models and patterns and give it a name (cat, house, circle, hole, etc.). Otherwise, it would be perceived as a texture, surface, or space, but not as a form. Therefore, form has limits.

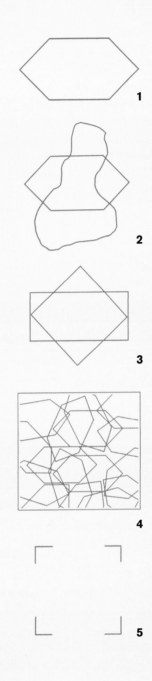

1

2

3

4

5

Gestalt psychologists defined the basic law of visual perception in the following manner: "...all stimulation schemes tend to be seen in such a manner that the resulting structure is as simple as allowed by the given conditions." We shall see how this irregular hexagon is clearly perceived when presented in isolation **(1)** or in the company of another form with very different characteristics—curves **(2)**; but how it perceptively disappears when shown in the context of similar characteristics—triangles **(3)**. The mind always tends to find the easiest way; in this case it perceives a square and a rectangle instead of a hexagon surrounded by triangles. If the context is excessively complicated **(4)**, the form completely disappears and a texture or surface is perceived.

According to the perceptive law of closure, the mind perceives figures even though they are unfinished. In this case **(5)** we perceive a square and not four independent corners.

Some forms present ambiguities or double meanings. The arrows **(6)** can be perceived pointing upward or downward, depending on whether the mind is focused on the positive or the negative.

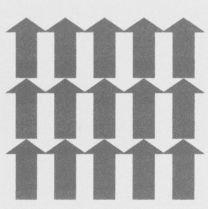

6

The Limits and Structure of Form

When defining form we can refer to two aspects of it:
1. its true limits: mass, line, and volume
2. its structural frame, created in the mind during the perception of the form and which, occasionally, coincides with those limits.

 We can, then, graphically represent the form from either of these two aspects. If we do so using its limits, we have several options. The first is to draw the silhouette to define its spatial limits, that is to say, its mass; the second is to represent it drawing the contours of the physical characteristics, and the third, expressing the volume using chiaroscuro. If we choose to define it using the structural frame, we should resort to the simplest and most definitive sketch of the form. If, for example, we wish to explain to someone in a quick, simple way what a spiral staircase looks like, we would draw an ascending spiral (its skeletal structure), and not the contours, silhouette, or volume (its limits). The structural frame of each form is derived, as Arnheim says, "from its surroundings based on the law of simplicity: the resulting framework is the simplest structure that can be obtained from the given form."

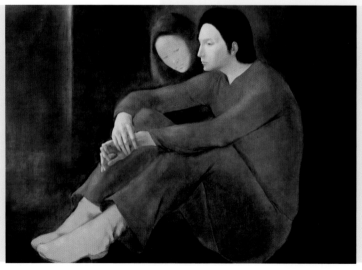

Montserrat Gudiol,
Seated Couple, 1975.
Private Collection.

We will begin with a figure from this painting by Gudiol (born 1933) to analyze the different perceptive levels of form: its structural frame, its mass (silhouette), its linear limits (edges), and its volume (chiaroscuro).

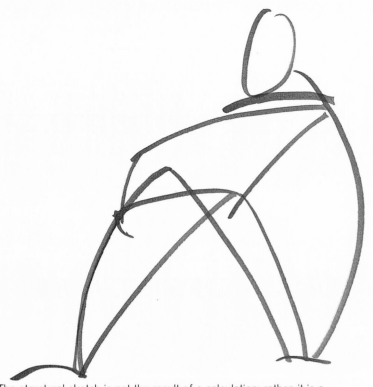

The structural sketch is not the result of a calculation; rather, it is a simple and intuitive description, which is almost always defined by the directions and angles of the form. When drawing a human figure, this means working with very simple lines of tension, axes, or geometric figures like triangles, ellipses, rectangles, trapezoids, etc., which rarely coincide with the outlines or with the actual skeleton.

The silhouette is defined by the limits that the mass of the form occupies in space. A silhouette has no details, but can get across the essence if the form is well positioned. The clearest examples of defining the form with a silhouette are found in Chinese shadows and in the profile portraits in cut-out paper.

Lines are a useful graphic technique for defining the edges and the morphology of an object. The lines can be used to draw not only the outside edges of the form (outside outline), but also the internal characteristics (inside outlines), so that a few well drawn inside outlines can explain the whole form, as can be seen in this example.

Without light there is no visual perception. Therefore the form of a body is directly defined by the effect that the light has on it. The most faithful way of representing any visually perceived form is through chiaroscuro. This technique distributes the light and shadows, defining the volumes of the body and giving it three-dimensionality and presence.

Typology and Characteristics of Form

The classification of a form is based on different criteria: its origin, structure, how it occupies space, rhythm, clarity, complexity, etc. A form should always be defined after analyzing it from all these points of view to avoid classifying it in a closed system. The typologies primarily help by supplying the necessary vocabulary for defining the characteristics of each form.

From all the possible classifications, we have chosen to group forms based on two general criteria: according to their origin and according to their visual characteristics.

Classifying Forms According to Their Origin

When speaking of their origin, forms can be natural or artificial. The group of natural forms can be divided into organic forms (animate or inanimate, animal or vegetable), mineral forms (stones, mountains, cliffs), atmospheric forms (clouds, gases, fog), and fluid forms (liquids, electric).

There are four kinds of artificial forms: geometric (architecture, furniture, machines), graphic (signs, symbols, diagrams), surface (fabrics, screens), and fantastic (dream forms, abstract).

Classifying Forms Based on Visual Characteristics

Morphologically, we classify forms according to several aspects. If we focus on how they occupy space, we can make out three groups: two-dimensional (these are flat shapes, such as signs, silhouettes, and outlines), three-dimensional (when forms have relief, volume, or spatial depth), and luminous (ethereal, transparent, reflective, or bright forms).

If we analyze their degree of clarity, forms can be more or less descriptive, ambiguous, diffused, distorted, contrasting, or focused. This aspect directly affects the degree of perception and recognition of the form. If we classify them by rhythm, they can be static or dynamic, to the point that they can look fast, like forms depicted in Futurism.

If we consider their complexity, we find simple forms and compound forms, which may consist of groups of several forms like those developed in Cubism, for example. Finally, all of these forms can be classified according to their structures, which can be geometric (graphic, flat, or polyhedral forms), volumetric (modeled, folded, etc.), porous (of atmospheric, vegetable, or animal origin), or linear (curved, twisted, sinuous, gestural forms, etc.).

Volumetric Forms, organic, curved…

Dynamic Forms, animal, living…

Spatial Forms, juxtaposed, broken…

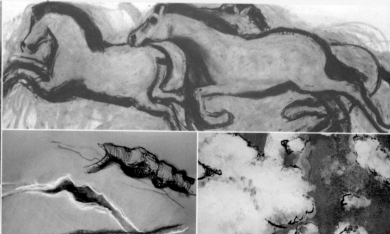

Simplified Forms, descriptive, bordering…

Linear Forms, twisted, sinuous…

Porous Forms, atmospheric, faded…

natura

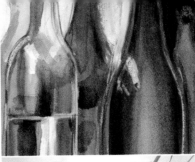

**Transparent
Forms,**
reflecting, shiny…

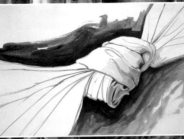

**Modulated
Forms,**
textile, folded…

Cubist Forms,
angular,
geometric…

Flat Forms,
architectural,
cutouts…

artificial forms

**Futuristic
Forms,**
overlapping,
divided…

**Organic
Abstract Forms,**
gestural,
serpentine…

forms

**Geometric
Abstract Forms,**
graphic, flat…

**Liquid
Forms,**
aqueous,
flowing…

**Modeled
Forms,**
corporeal,
contrasted…

Form in the Painting

Although all four elements of visual language (form, color, space, and line) are present in a painting, they do not always have the same importance, since each artist develops one or more of them in a special way.

Expressionism was one of the main artistic movements that used form to articulate the message. The Norwegian painter Edvard Munch (1863–1944) began his career during the Impressionist period, but he soon disassociated himself, like Van Gogh, with his more Expressionist personality.

Munch expressed himself using a system of wavy forms that often swirl into spirals. Some faces do not have features, on occasion they have diminutive or exaggerated eyes, and at other times they have a skull-like aspect that is reminiscent of death masks. His personal universe of forms that are phantasmagoric and real at the same time communicate the loneliness and anguish of his subjects. As Rilke said about him (perhaps thinking about *The Scream,* "he had now introduced the violence of terror in his lines," which is nothing other than energy that flows and materializes. In his work *The Scream,* the sound effect takes on form and deafens the viewer.

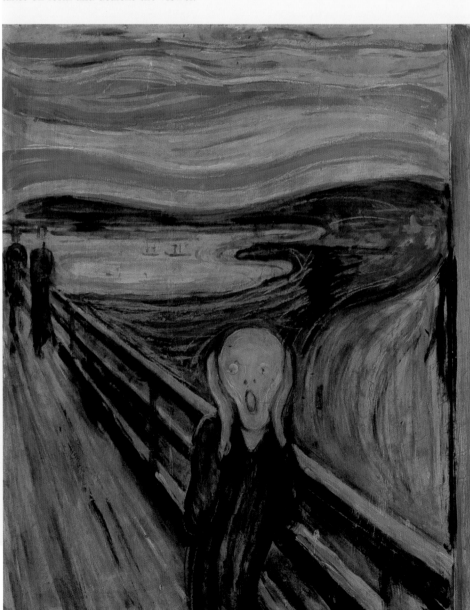

Edvard Munch,
The Scream, 1893.
Nasjonal Gallerief,
Oslo (Norway).

"I was walking with two friends along the path, the sun was setting. The sky suddenly turned red. I stopped and, tired, I leaned on a railing. Over the city and the dark blue fjord I saw nothing but blood and tongues of fire. My friends continued walking and I remained in the same place, trembling with fear, and I felt an infinite scream that penetrated all of nature."
Edvard Munch,
1892.

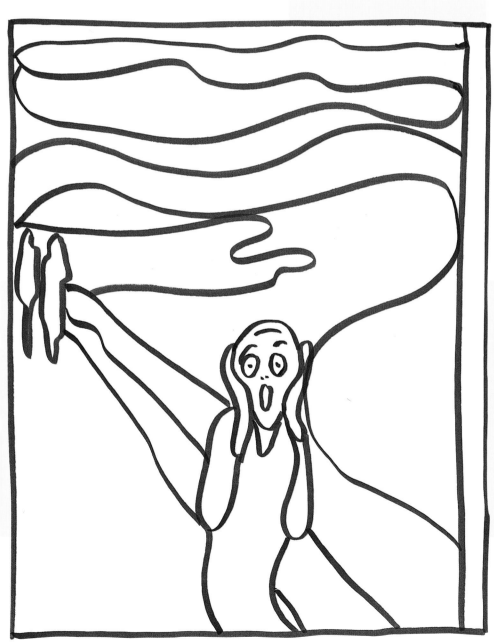

Here is a graphic sketch of the forms that make up the overall image of Munch's painting. The shapes of the people and the elements of the landscape can be easily recognized because of the simplicity of the structures.

Form and Personal Expression

Each form expresses different content. An angular and complex form does not communicate the same idea as one with soft curves and a simple structure, nor is a dynamic and gestural form the same as a static and geometric one. A single subject can be approached from multiple points of view, as many as there are artists. We will see how the human figure has been formally developed by four great artists.

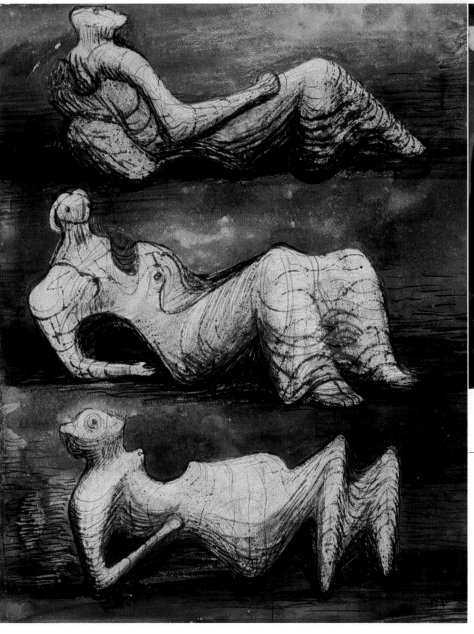

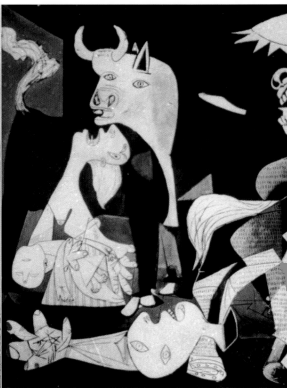

Henry Moore,
Reclining Figures, 1948
(page from a sketchbook, 1947–1949).
Private Collection.

Using volumetric forms conceived as real sculptures, Henry Moore (1898–1986) focuses on the most corporeal dimension of the human body, developing the mass and the volume of the anatomy but interpreting these aspects from a personal and creative vision.

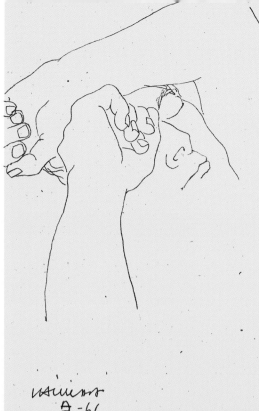

The hands and tools were a source of inspiration in the work of Eduardo Chillida (1924–2002). As a sculptor he always connected his formal universe with the value of space and the concept of strength. In this drawing, he describes overlaying masses and forms with a delicate but precise line.

Eduardo Chillida,
Hand Series, 1966.
Private Collection.

Joan Miró (1893–1983) paints the human figure as a sign. Each stroke suggests a form, and the artist converts it into a person who plays a symbolic and poetic role in his own visual universe. Using simple and primary forms, Miró places us in an unreal dream world.

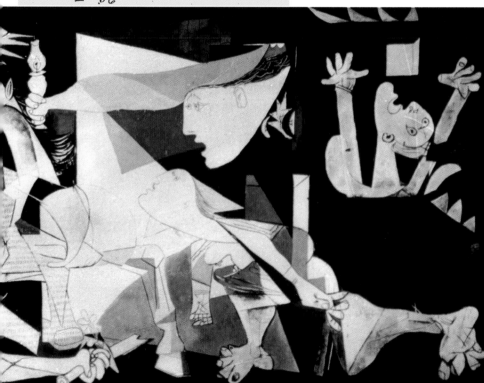

Using flat forms similar to the language of posters, Pablo Picasso (1881–1973) created this immense epic painting that expresses the disasters of war. The horror is translated in each expression of anguish.

Jagged, fragmented, and deformed shapes go beyond traditional formalist Realism and Cubism to become a denunciation.

Pablo Picasso,
Guernica, 1937.
Centro de Arte Reina Sofía, Madrid (Spain).

Joan Miró,
Page from the artist's book: *À toute épreuve,* 1958.
Private Collection.

Experimenting with Form

Each artist has a personal vision that is born of his or her interior world and is transmitted using a personal language, but the interior world and personal language are not constructed from nothing. The artist makes his or her way through work and contemplation, enriching the language and amassing content that is later communicated. Many artists dedicate hours to observation and analysis of the world that surrounds them. They strive to capture that which is hidden behind every form, and in that way connect with nature and the culture of that moment.

In this series of paintings, Tomás Gómez (born 1960) develops a formal study of a human figure, modifying the perception of its morphology by changing the point of view and the creative application of foreshortening. Without changing or deforming the model, the artist creates three personal forms, preserving the initial realism and adding a creative vision.

Tomás Gómez,
1966, 1989.
Private Collection.

Just like Miró, Chillida, and many other great artists, Henry Moore collected, during more than sixty years, all kinds of natural forms: coral, skulls, bones, roots, etc. His friends always brought him objects that he used for inspiration in his creations, always searching for the heartbeat of each natural form that would connect it to the human figure. This is a page from one of his many sketchbooks that he filled with drawings and form studies throughout his life.

Henry Moore,
Page from a sketchbook, 1937.
Private Collection.

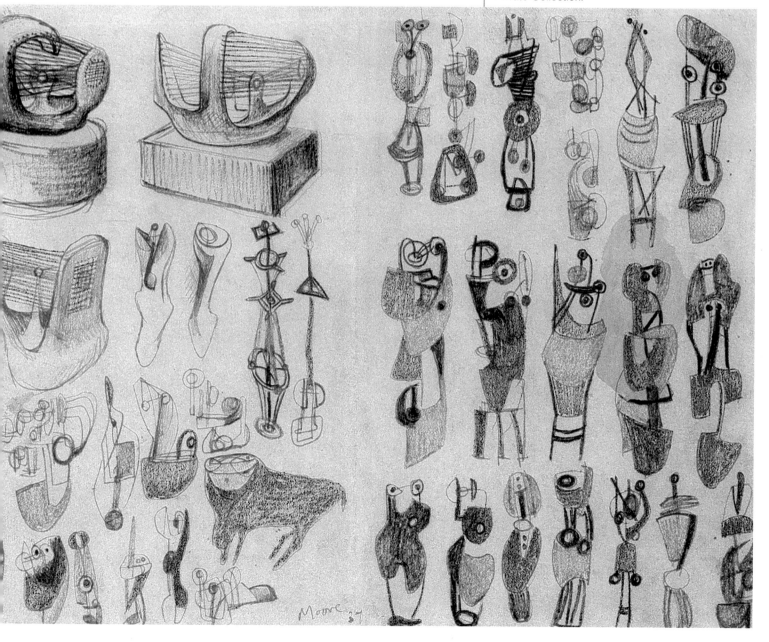

In this chapter we will analyze the forms that are most frequently found in living nature: the animal and plant forms. We have chosen three very different models to suggest creative approaches based on their specific characteristics, although despite their different visual qualities, what all three have in common is the fact that they are organic forms. They are some fruit, with simple and volumetric forms, some twisted branches, with a linear structure and expressive character, and finally, some galloping horses, with very dynamic and complex forms.

Form in

Living Nature

"Let the students experiment with how a bud is formed, how a tree grows, how a butterfly opens: they themselves will be as rich, as voluble, as obstinate as grand nature."
Paul Klee,
Methods of Studying Nature, 1923.

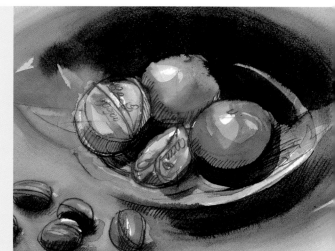

Volumetric, Organic, and Curvilinear Forms

Creative Approach 01

Paul Cézanne (1839–1906) was the first painter to consider the painting as a living thing independent of nature, with an internal logic. Form was the focal point of most of his works, and he gave them a greater solidity, through a balanced use of weight and color, than did his Impressionist contemporaries. His method of working was based on careful, almost scientific observation of the object that he wished to represent. He made numerous studies of a single form from various points of view or in different light, as illustrated by a series of paintings of Sainte-Victoire mountain in France, or the many still life paintings of apples. For him nature was the only art school, and in it he discovered that which he formulated in his famous theory that reduces all forms to the sphere, the cylinder, and the cone, three figures of circular structure, like the cycles of nature.

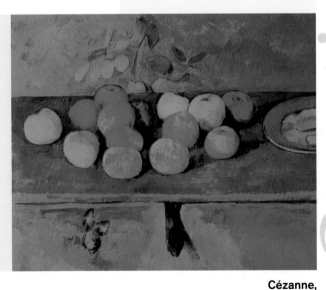

Cézanne,
Still Life with Apples and Plate of Pastries, c. 1881.
Musée du Louvre,
Paris (France).

Composition with the Fruits of Autumn: Analyzing Their Structure and Volume

The first approach in this book is a morphological study of simple elements of nature. Just like Cézanne, the author of this project, Josep Asunción, is going to analyze the internal structure of some fruit and define its volume step by step. The analytical method begins with the first question an artist should ask: "What is the structure of the model?" From here he or she can begin adjusting the volume using chiaroscuro. As will be seen in this approach, working analytically does not hinder the resolution of the painting through the use of loose and free lines, since a good structural base is what is important. The medium chosen by the author is color inks, applied with pencil and brush on paper, and the model a grouping of pomegranates and walnuts with spherical structures and curvilinear forms.

"Depict nature using the cylinder, the sphere, and the cone."
Paul Cézanne.

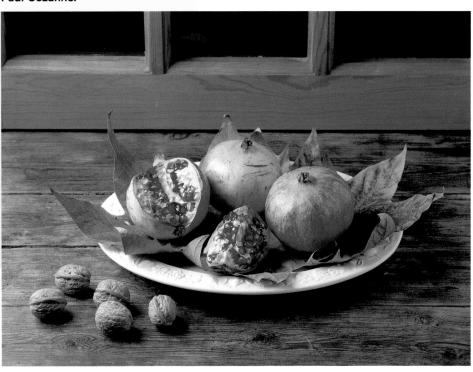

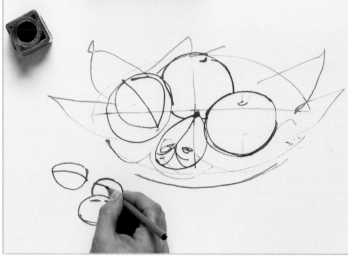

1 The first step is to look. A careful look at the form will allow us to discover its structure, its essential characteristics. The second step consists of deciding on the ideal representation of this structure (as we saw in the introductory chapter, this could be its structural framework, outline, silhouette, or masses). In this case, the best way is to begin with the outlines. Using a medium hard (HB) pencil dipped in ink, we draw the essential internal and external lines of each piece of fruit.

2 Using a wide watercolor brush, we apply a light wash while the colors of the outlines are still wet. The base color is a neutral tone that will be used to establish the principal masses.

3 After adding two more walnuts to the composition, the following brush lines place the shadows of the forms. In this way, the form ceases to be two-dimensional and becomes three-dimensional, since its own shading creates the volume and the projected shadows situate it in space.

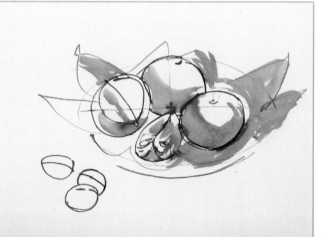

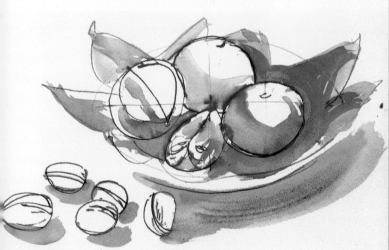

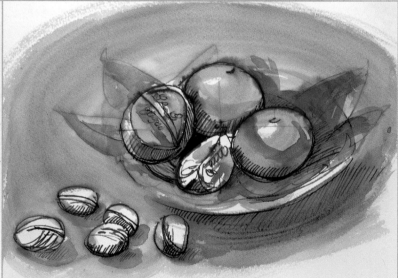

4 Hatch lines made with a pencil dipped in ink further define the volume of the walnuts and pomegranates, and add vibration because of the tension between the line and the wash. Then, the background is painted with a neutral wash applied with a wide brush, following the elliptical rhythm of the forms to integrate the composition and give it a dynamic quality.

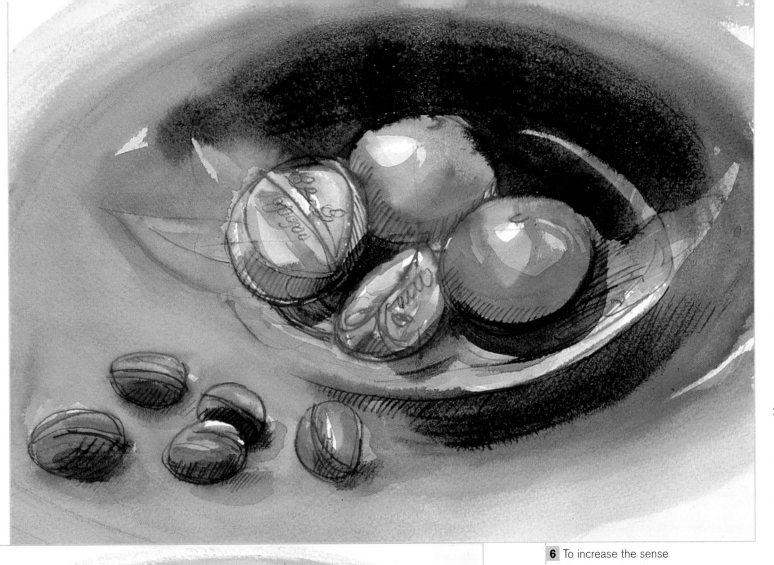

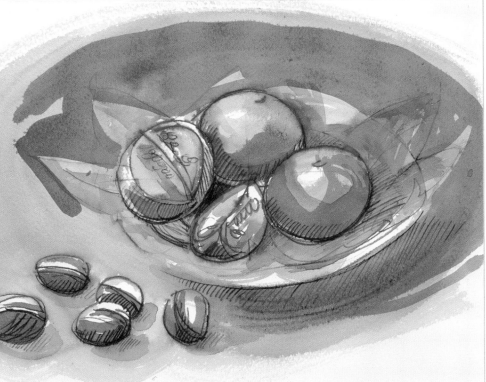

6 To increase the sense of vibration and make the form stand out from the background, the surrounding areas are painted green. Green is a cool tone that contrasts with the orange form. The final touches consist of applying a very dark ink that emphasizes the volume and adds solidity to the grouping.

5 We continue to create the volume of the spherical forms by applying new values of light and color with a warm-color ink that will increase the contrast.

Other Versions

When using organic forms with spherical structures, the entire creative approach can be handled with exactly this type of curvilinear form, varying the distribution of the masses and the intensity of the contrast of the volumes. The author offers several possible approaches using these artistic guidelines.

The sensation of freshness produced by this painting is due to the unfinished feeling of the composition. A few well-placed lines, and respect for the cleanliness of the white paper background that shows through the washes, add luminosity to the scene and allow the visual expansion of the form.

Here the author achieves a darker and more dramatic effect. To do this, he has used more intense colors and black at the end, which outlines the form and isolates it from the space partially showing its volume.

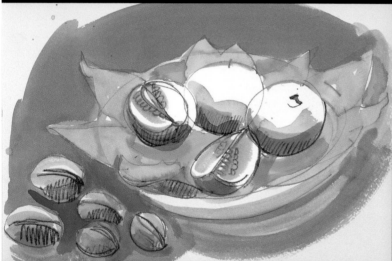

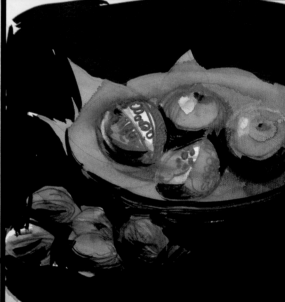

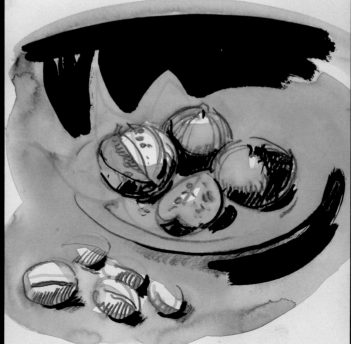

In this example he has chosen to strengthen the fruit by blurring the plate with very diluted ink. The dark streaks in the background create a visual counterweight that balances the distribution of light and shadow.

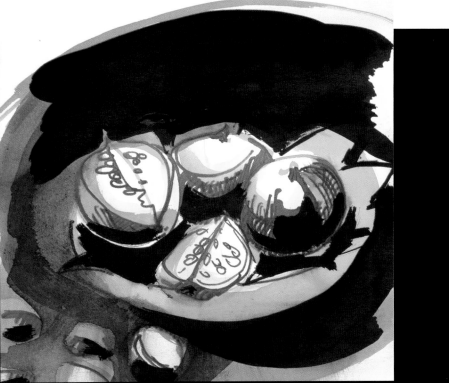

A very wet application of a sepia tone softens the forms in this painting, creating a uniform atmospheric feeling that perfectly integrates the volumes of the pomegranates and the walnuts in the space.

In this case, the author has chosen irregular and flat forms, with a small value range but very strong contrasts.

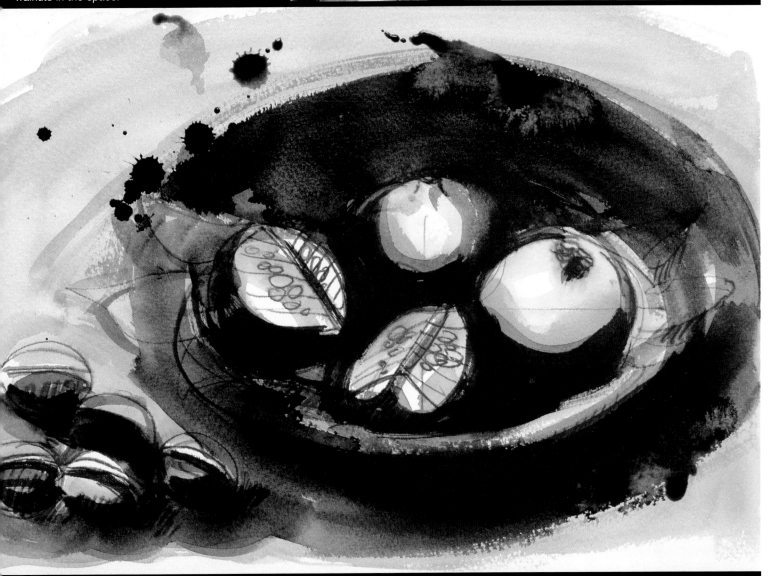

Window

New Approaches

Other Models

Most organic forms in living nature have a curvilinear structure. The plant world is very rich in forms of this type. The artist has chosen different fruit for this project: a pumpkin, framed by arcs around an axis, two pears with an ovoid form, and a group of grapes and cherries, with round shapes. The variety of sizes and the arrangement of the axes in the structures add more complexity to the theme.

Other Media

To change the medium and experiment with new approaches, we have decided to illustrate the subject using an oil-base medium, wax crayons. This medium allows the colors to be blended on the support. By making them thick and creamy, it is possible to create a rich pairing of line hatching and textured blending. The result is much more atmospheric, the form does not become separated from the background, and a greater tactile sensation is added by the texture of the lines.

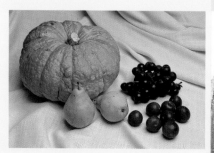

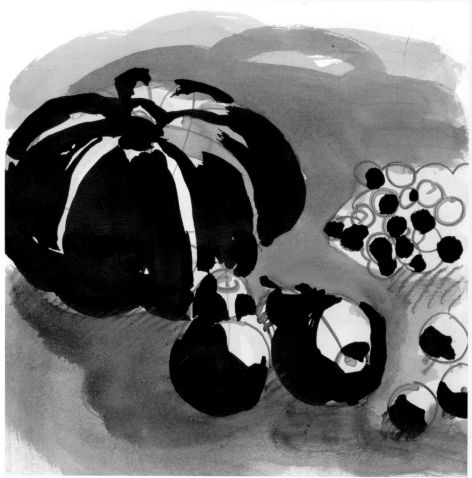

Other Views

Light visually defines form. Each painter treats form differently, depending on how he or she chooses to distribute light and shadow. Zurbarán (1598–1664) interprets the organic forms with characteristic intimacy and delicate simplicity, using a dark chiaroscuro to endow each quince in the painting with a soul. Botero (born 1932), on the other hand, is characterized by his tendency to make everything he represents as round as possible. This exaggerated roundness distends the forms and makes them charming, even amusing. The soft and fresh light of the oranges makes them almost incorporeal.

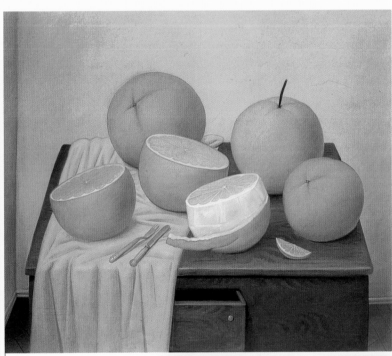

Fernando Botero,
Oranges, 1982.
Private Collection.

Francisco de Zurbarán,
Still Life with Quinces,
c. 1630.
Museu Nacional d'Art de
Catalunya, Barcelona
(Spain).

Linear, Twisted, and Sinuous Forms

Creative Approach 02

Van Gogh (1853–1890) is a painter who shines with his own light in the constellation of the Impressionists. His unique style, based on a very personal treatment of color and form, as well as the direct, vibrant, and energetic line in his paintings, made him the precursor of Expressionist painting.

A passion for nature led him to paint outdoors again and again, to seek the energy contained in each form and to communicate its strength. That is why he often drew and painted trees, for the life he could see in them, capturing the character in each branch and expressing it through twisting, undulating, and vibrant lines. These linear forms, extensively used by this great artist, were even applied in representations of other elements of the landscape and the still life. The sinuous lines that modeled reality with such great dynamism made his style unmistakable.

Van Gogh,
The Garden of the Presbytery in Winter, 1884.
Van Gogh Museum,
Amsterdam (The Netherlands).

Trunks, Branches, and Roots: Discovering Their Expression and Poetry

A second group of natural shapes is made up not of volumetric, but of linear forms. There is little volume in these forms, they are defined by the paths of their lines, whether straight, curved, sinuous, broken, or twisted back upon themselves. The following creative approach, developed by Josep Asunción, examines the forms of a natural growing branch. Using this simple model, the artist has focused on the gesture and the rhythm of its lines, very creatively combining several points of view of the same branch in a single drawing. Dry media, a combination of graphite pencil and hard color pastels, are used to enrich the color of the work.

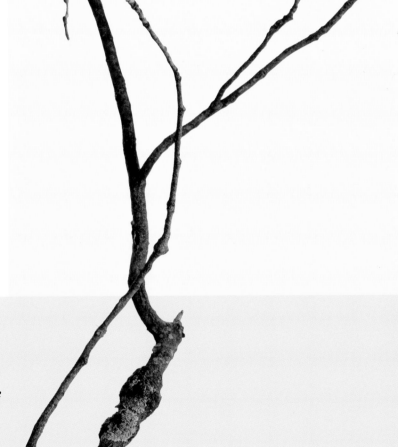

"The eye has the ability to enjoy winding roads, twisting rivers, and all kinds of objects whose forms, as we shall later see, are mainly composed of what I call the undulating and serpentine. (…) An intricate form, then, I will define as the peculiarity of lines that compose it, that carry the eye in a capricious kind of persecution, and, by the pleasure it gives the mind, titles it with the name of beauty."
William Hogarth,
The Analysis of Beauty, 1753.

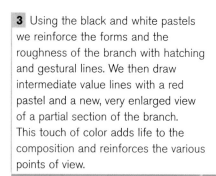

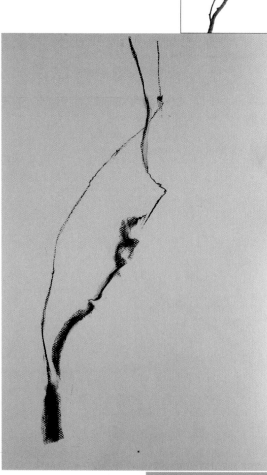

1 The first mark that we make with black pastel already defines the linear character of the branch. Since we are dealing with a modulated line, we also vary the line as we move the pastel across the paper, changing its position and intensity; this way we achieve a combination of thin and thick strokes.

3 Using the black and white pastels we reinforce the forms and the roughness of the branch with hatching and gestural lines. We then draw intermediate value lines with a red pastel and a new, very enlarged view of a partial section of the branch. This touch of color adds life to the composition and reinforces the various points of view.

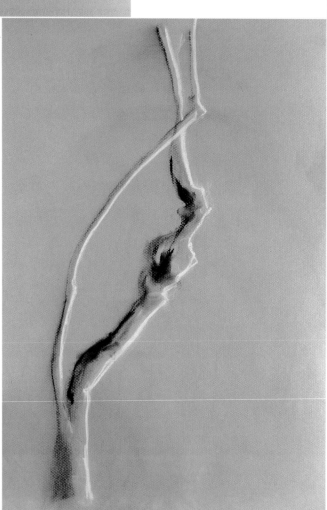

2 Then we draw the outlines of the light areas with a hard, white pastel. The combination of light and dark lines suggests the volume of the form. We blend the dark lines with a finger to soften them and further modulate the branch.

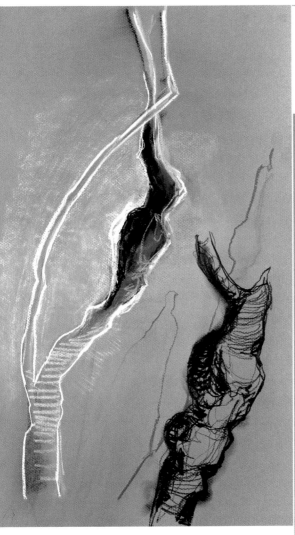

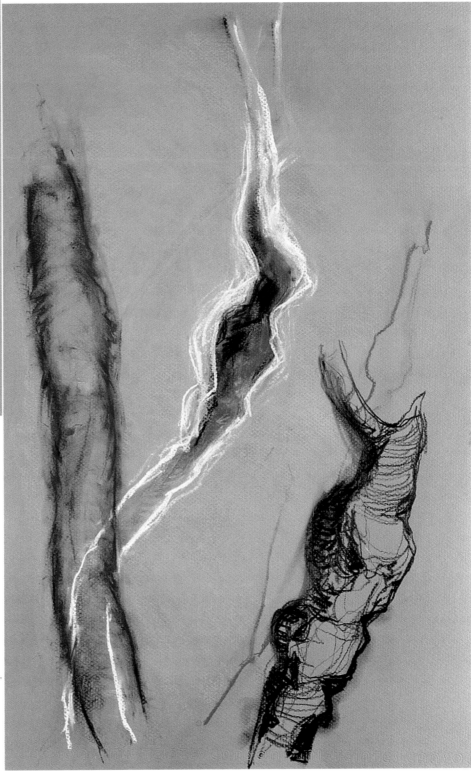

4 We draw another very enlarged part of the branch with very soft graphite (6B) to contrast with the fine lines of the red branch, partially blending some lines and modulating the volume with combined linear hatching. We reinforce the outline of the first branch with white to compensate for the dark mass.

5 To finish, we adjust the shapes, erasing some of the previous lines and creating a fourth fragment of the form, bluer and more uniform, to create a more varied and balanced composition.

Other Results

The creative work in this approach consists of freely changing the sizes of the branches, their structure, and the distribution of the different combined points of view. As illustrated in these six different approaches, experimenting with the form makes a big difference, as does changing the support. The results are more or less expressive, depending on the paper used.

In this composition with branches the artist wanted to emphasize the diagonals and the idea of thin linear shapes. By repeating the branch several times in the same position, changing the scale a little and especially the technique, he has converted the diagonal into a repetitive and insistent linear form that has great dynamism.

The purity of form in this vertical branch is the ideal subject for communicating the force of a simple linear movement in space. Since only the outline has been drawn in this case, the branch has become practically transparent and delicate. The quality of the handmade paper also lends a distinct character.

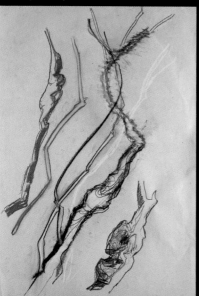

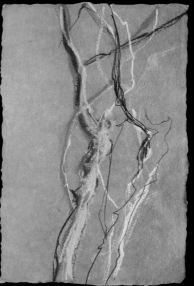

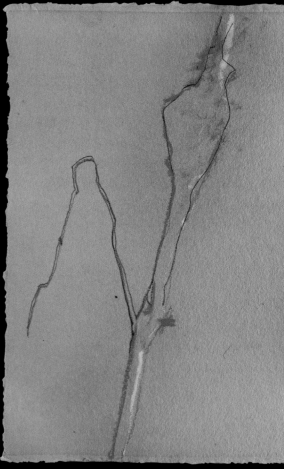

In this case the branch is repeated in the same position, without undergoing any variation in scale, only in structure. The structure of the branch on the right is drawn with an outline, and the one on the left is drawn as a mass. Combining the structural forms creates a beautiful dialogue between them.

This is the most expressionistic
representation of the branch. In it
the author focuses on the knot and
exaggerates its volume and mass
with heavy black lines and repeated
hatching created by several light zigzag
strokes with an eraser. A small shape
drawn next to it helps make the knot
look larger through the simple contrast
of scale.

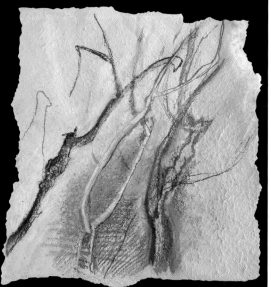

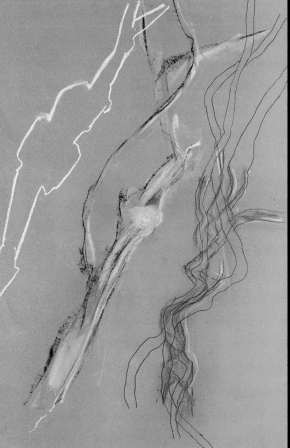

Several versions of the same branch
have been drawn on a piece of
handmade paper, this time emphasizing
the dialogue between the branch and
the background. The intensity has been
varied to make the body of the lines
stand out even more.

For this approach the artist has chosen a larger sheet
of recycled paper and combined three very different
forms on it. The uppermost one is schematic and
simple, the middle one is a soft, blended form,
and the lowest is a very twisted and tangled shape
of sinuous branches.

New Approaches

Other Models

An endless number of linear forms can be found in natural elements: twisted, sinuous, straight, undulating, serpentine, jagged, etc. For variation the artist has chosen some more undulating and sinuous, with soft curves, more typical of a climber than a tree or bush. He has approached the challenge in two different perspectives. In one of them he has emphasized the undulations by drawing smooth lines on a handmade two-color decorative paper. On the other he has exaggerated the energy of the three tangled branches, using very strong gestural strokes to create more jagged forms.

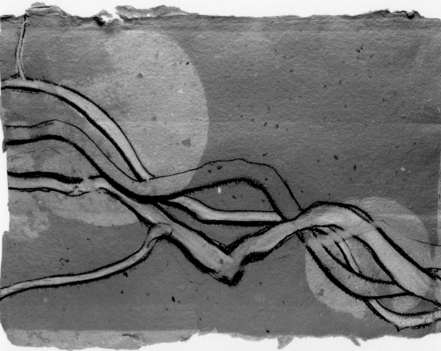

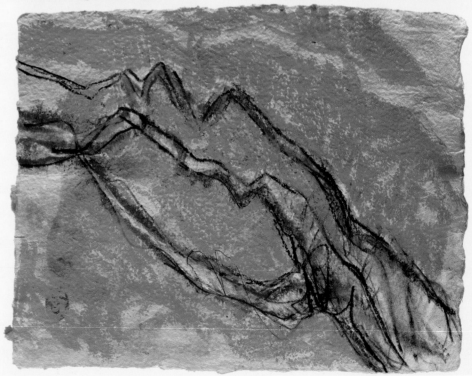

Other Media

It is possible to create linear forms like this using drawing ink and a drinking straw. A large drop of ink is deposited on not very absorbent paper, the straw is aimed at the ink, and we blow until we can move the liquid around, creating interesting trails.

Other Views

The view of sculptor Henry Moore (1898–1986) regarding trees was focused on the dialogue between the masses and space. In this drawing, Moore depicted the tree as a very dense and living volume that expands in space, extending its branches and creating a curtain or a textural barrier of lines. Egon Schiele (1890–1906) treated the linear forms of the plant world in a more painterly manner, emphasizing the lines of the branches, the expressiveness of their knots, and the value of the empty space that caused the lines to vibrate.

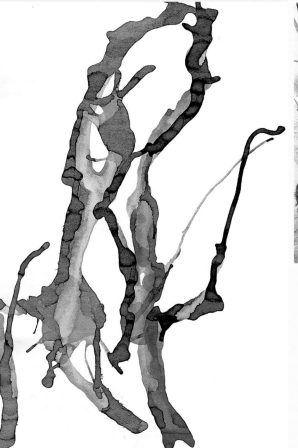

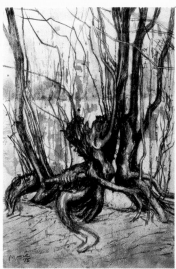

Henry Moore, *Trees IV,* 1975. The Henry Moore Foundation, Perry Green. Hertfordshire (United Kingdom).

Egon Schiele, *Plum Tree with Fuschias,* c. 1909. Hessisches Landsmuseum, Darmstadt (Germany).

Dynamic, Animal, and Living Forms

Franz Marc (1880–1916) was, along with Wassily Kandinsky (1866–1944), one of the founding members and driving force of the group of German artists known as *"Der Blaue Reiter"* (The Blue Rider). He worked during the first years of the 20th century, in the cultural context of an explosion of avant-garde movements. Animals, especially horses and deer appear in nearly all of Marc's paintings. But for him animals were something more than simply subjects for painting, they were a spiritual connection with nature. Although he had lived with animals from the time he was born, he discovered his artistic interest in them after an encounter with Niestlé in 1905. Marc became fascinated by his large painting, in which one hundred starlings were represented. He said of this picture in a letter, "One can almost hear the chirping and fluttering wings of the birds… and none of them look alike! Each animal has its own expression."

Marc was not interested in description, but in giving form to the strength and vitality of each living creature. This idealization of nature is the reason that many of his horses are blue.

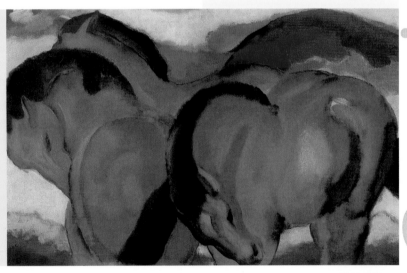

Franz Marc,
Small Blue Horses, 1911.
Staatsgalerie Stuttgart,
Stuttgart (Germany).

Galloping Horses: How to Develop Their Masses and Lines of Force

If forms are the representation of the souls of things, in other words, the container that carries the content, then living forms must contain and carry life. If the hard and petrified forms of a fossil communicate rigidity, stillness, and the sensation that time has stopped, those of an animal must transmit vitality, movement, and energy. In the following exercise we suggest developing a very lively subject: some galloping horses. The horse is an animal that symbolizes strength and energy, although not aggressiveness. Here, David Sanmiguel worked with a group of horses that he treated as a single composition. He has used structural organic forms based on arcs and ellipses, two very energetic and lively forms, to communicate their movement and to describe their anatomy in a creative way.

"We will never again paint the forest or a horse the way we like or the way we see them, but as they really are, like the forest or the horse feels, their absolute essence that lives behind the image that we see."
Franz Marc,
Artist's note, 1911.

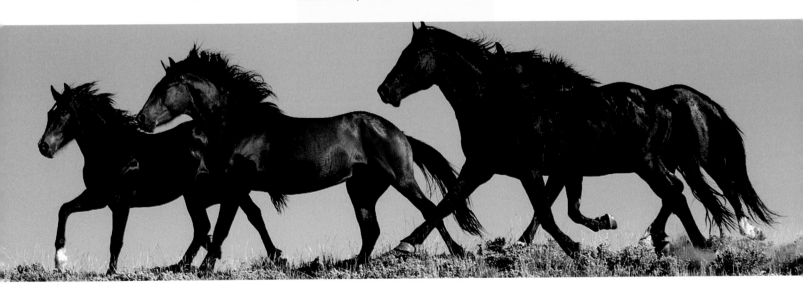

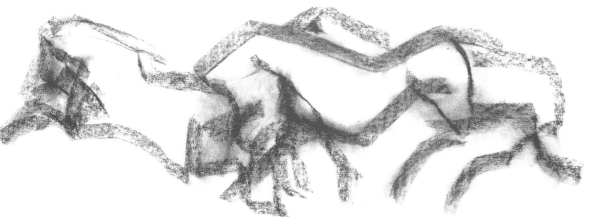

1 We begin with a horizontal format to communicate the idea of galloping and to center the forms of the horses visually in the scene. Sanguine crayon is the chosen drawing material, and the support is a durable paper. The first lines are more gestural than descriptive, but they define the main volumes and lines of force.

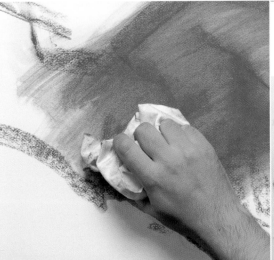

2 Since the very jagged forms do not express much movement, a more suggestive and blurred image is created. The first step consists of blurring the outlines of the form with a rag.

4 The entire drawing is erased leaving a background of insinuated forms.

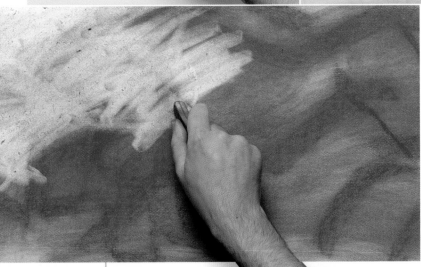

3 Next, the image is erased, using a curvilinear motion, in the shape of an arc, so that the marks of the erasing add texture to the paper.

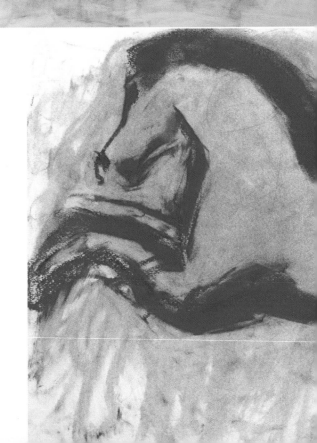

5 A new scene is drawn over this background, making sure that not all of the forms line up, thus creating vibrant lines and masses.

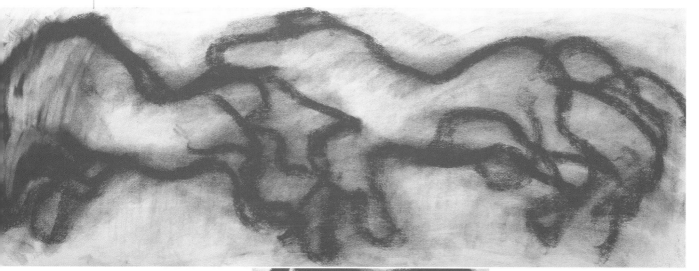

6 After repeated drawing, wiping, and erasing, a final drawing that purposely has a dynamic atmosphere is created, the result of working hard on the forms.

7 The finished work perfectly expresses the lively forms of the horses in a direct and dynamic manner, the visual vibration between the different layers created by the continuous process.

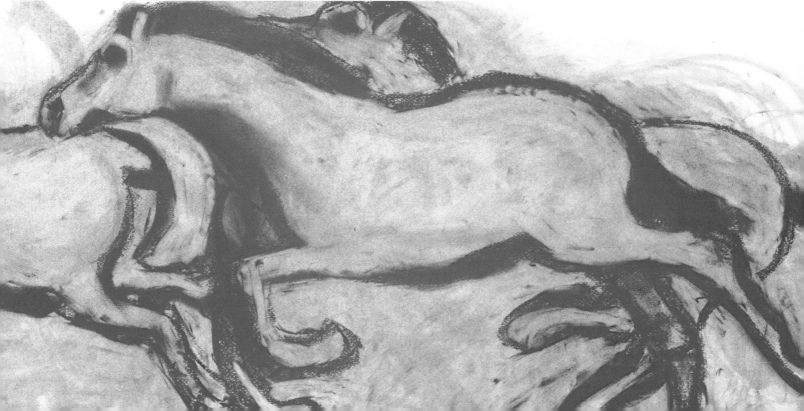

Other Versions

The forms of the horses are structurally defined with a solid and vigorous mass and extremities of a more linear nature. Changing this structure would mean betraying the personality of this animal, which would take us farther away from the object of this approach. But it is possible to modify the final results without changing the technique by focusing on different aspects of the form.

A schematic solution has been chosen for this version. Flat forms with heavy outlines, in the style of primitive art, have been achieved through contrast and erasing.

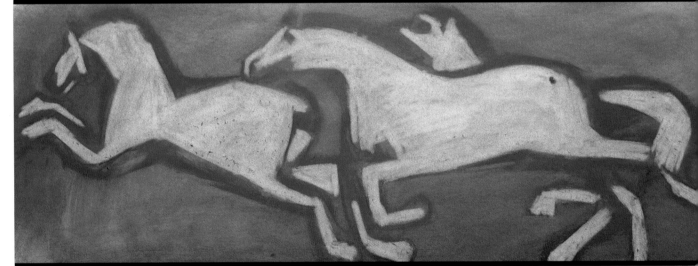

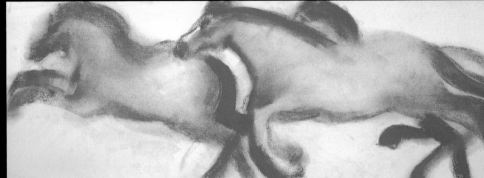

Using heavy strokes and hardly any lines, more airy and physical forms have been constructed. Wide strokes are the best way of creating a volume with density and body.

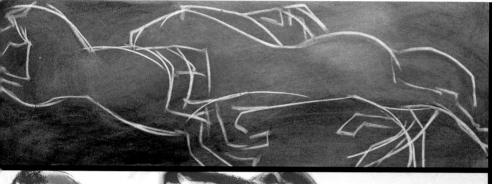

Here the artist has focused on working with the outlines. It is possible to achieve a very dynamic effect with just lines, although the result is more ethereal and mental than physical.

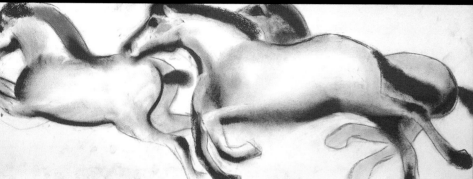

In this piece, the horses have a joyful expression. The light blending of the volumes and the outlined profiles give a fresh look to the forms in this scene. Varying the pressure in the outlines makes the forms very smooth.

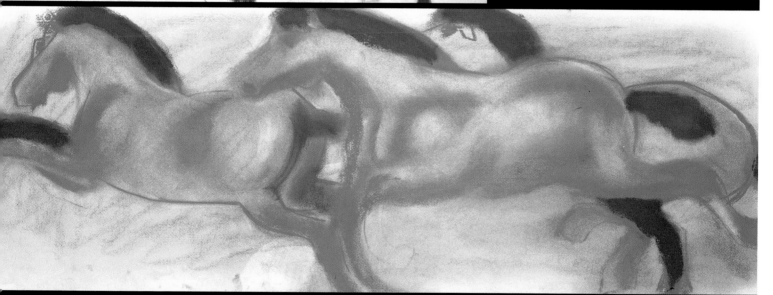

This time the volume of the horse's musculature stands out. The soft forms produced by blending model the relief of the bodies, and sinuous and suggestive lines idealize and help define the contours of the horses.

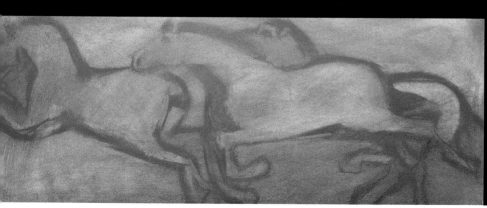

To integrate the forms of the group of horses in a unique atmosphere, with very little contrast, the artist has decided to conclude this work with heavy blending. The individual forms are suggested within a common whole.

New Approaches

Other Models

Every animal has a different, sometimes even opposite, morphological structure. For example, there is no commonality between the form of a snake and that of a sea urchin, or an elephant and a dolphin. But each one of these animals is a living creature, and moves in a different way. When working with the aspects of form in the animal world it is necessary to observe the models very attentively, making an effort to capture their volumes and gestures.

Let's look at how the same artist approaches a different model: a dog. Although the characteristic features are not that different from those of a horse, the vitality of the dog is more restrained because of the fact that the form is more static.

Other Media

Chalk, like sanguine crayon, allows erasing and blending to model the lines, and varying the energy and pressure of the lines and strokes. But these media do not allow the wet-media techniques, which are related to the dilution and fluidity of paint. The artist has made several watercolors emphasizing loose brushwork and the effects of wet on wet to create some outlines with less definition and a softer effect of movement. As we see in these small examples, the results are very lively and open the way for experimentation in this wet medium.

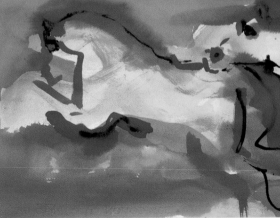

Other Views

The horse is perhaps the most represented animal in the history of painting, from prehistoric times until today. Its graceful figure and its proximity to man has made it a symbol of nobility, strength, and elegance.

In prehistoric times animals were represented for purposes of magic. Painting an animal produced a magical appropriation of it through its image. The artist's viewpoint formed part of the hunting ritual.

Leonardo da Vinci (1452–1519) dedicated many hours to the study of forms in nature. His interest was analytic and scientific, and he focused on the anatomical aspects of the animal.

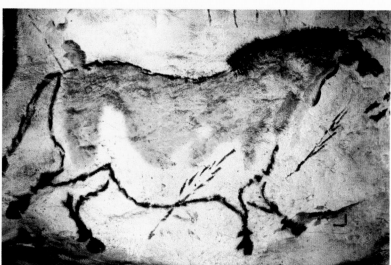

Cave painting.

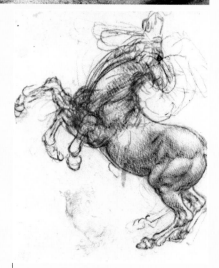

Leonardo da Vinci, *Horse.*
Royal Library, Windsor (United Kingdom).

Still life is the painting genre that is most focused on objects and their representation in the context of a setting. This attentive look at the objects requires work analyzing the forms, while at the same time it stimulates the painter to experiment freely with them, making the painting truly unique. Four different creative approaches are offered in this chapter. In the first we experiment with the forms of highlights, reflections, and transparencies, and in the second with the forms of folds and tension in clothing. The third approach deals with fragmentation and decomposing forms in the Cubist style, and the last with the flat and angular forms of furniture and interior spaces.

Form in

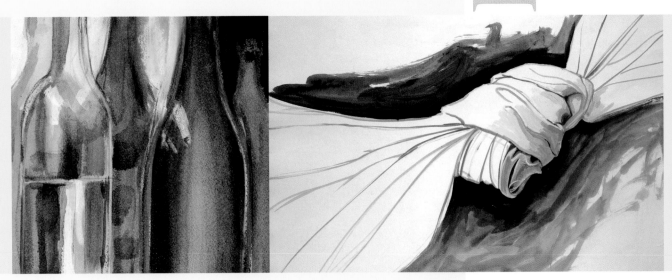

Still Life

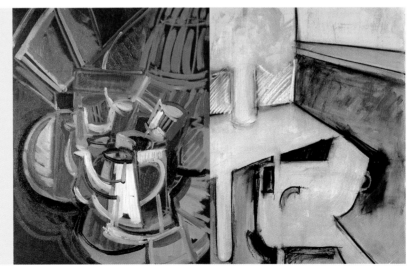

"*I dig around the kitchen looking for humble objects, any kind of object. I will make a painting from an ear of wheat and a cricket. To communicate emotion with these things we have to love them enormously, and you can be assured that if you do not, you will make a painting of no interest at all.*"
Joan Miró,
Letter to Roland Tual, 1922.

Bright, Transparent, and Reflecting Forms

Who has not been fascinated by the multiple changing forms of the inside of a glass piece illuminated by the sun? Or by the images reflected in a glass building, a mirror, or a display window? The subject of an image deformed by the effects of light and reflection is one of the favorites of Photo Realist painters such as Don Eddy (born 1944), who, in his prodigiously sized canvases, depicts complex and ambiguous images produced on polished, reflecting, and transparent surfaces. His series of glassware is famous, with its enormous visual complexity, like his display windows, which allow the interior to be seen along with the street that is reflected in the glass. Photo Realism, also known as Hyper Realism or Super Realism, is a painting style that emphasizes painting virtuosity, reformulating the image with such detail and purity that the results are truly disturbing.

Don Eddy,
Glassware I, 1978.
Private Collection.

Transparencies, Highlights, and Reflections in Glass Objects: Finding Forms Within Other Forms

In this approach we are going to exaggerate the richness of forms caused by the effects of light in transparent materials: highlights, reflections, and transparencies. The artist, Josep Asunción, has created a still life by placing a group of bottles in front of a window to allow light to pass through the glass to create a magic universe of changing forms. He has framed the central bottles, finding an endless number of forms inside of forms in this part of the composition, a truly suggestive motif. Watercolor is the medium he has chosen for this, since it is ideal for expressing such qualities as transparency and luminosity.

"A form in relation to other forms constitutes expression."
Hans Hofmann,
Participating in a round table in "Artist's Sessions at Studio 35," 1950.

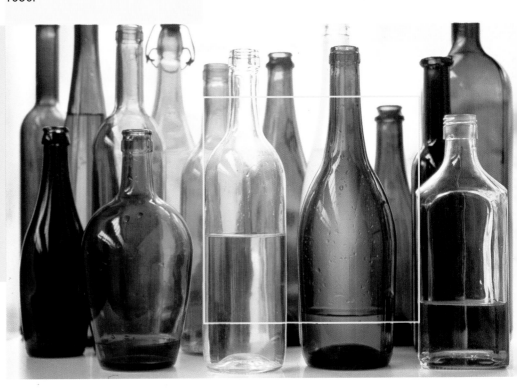

1 Blocking in the work begins with an initial sketch of the structural framework of the forms, made with a soft graphite pencil. In this case, they are open and juxtaposed forms that we will discover by carefully observing the interior of each bottle. The structure follows a rhythm of vertical lines and slight undulations of a wavy or sometimes parabolic shape.

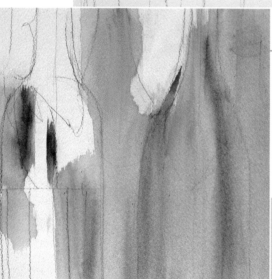

2 The first brushstrokes are placed using very diluted watercolors, ensuring that they are ambiguous and not outlined, blending them on wet to create airiness. This effect will be the basis of the visual sense of gradations of glass.

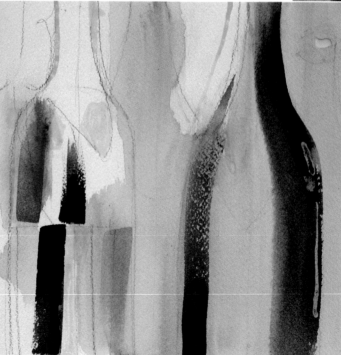

4 We apply a reserve mask so that the areas where we want highlights will not be painted. Then, we continue working with the gradated tones on the green bottle to give it volume, as well as the contrasting forms on the white bottle. We also tackle the bottles in the back.

3 The polished and reflective materials create hard contrasts in the reflections and highlights. This characteristic allows the viewer to know that he or she is looking at a material that is smooth and transparent, not opaque and matte.

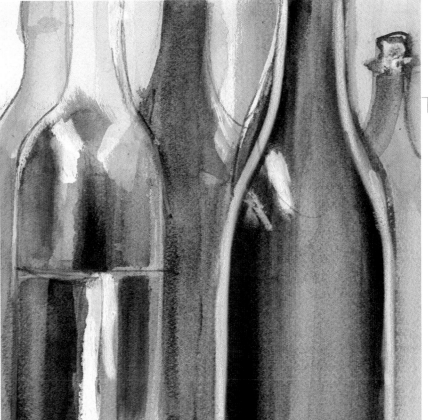

5 The intensity of the colors are increased to better define the edges of each bottle, as well as the material and body of each one. We go over the outline of the green bottle to reinforce its form and keep it from getting lost as we continue working.

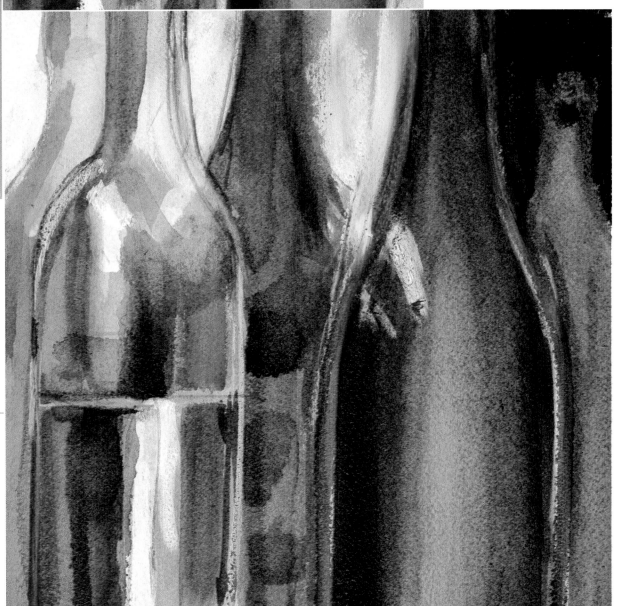

6 Finally, we intensify the background and the amber tones of the rear bottle. This is done to make the highlights and transparencies of the white bottle in the front especially stand out.

Gallery

Other Versions

Like a kaleidoscope, this group of bottles is truly a source of multiple forms that vary according to the point of view of the spectator and the position of the light source. The artist wanted to emphasize the different forms in each one of the following approaches. Density and transparency are the two visual aspects that he played against each other, adjusting the intensity of the color more or less according to the desired effect.

This watercolor shows a peculiar way of interpreting the forms inside the bottles. The artist wished to express the psychedelic light effects generated by the silhouettes of the curved and sensual edges by using flat areas of color without blending or gradations.

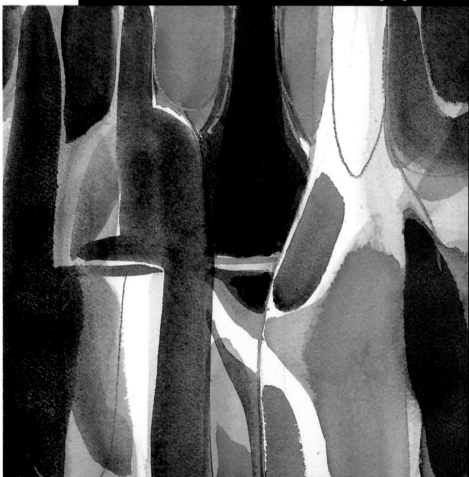

In this wonderful composition the artist has risked painting the basic structure of the forms directly but subtly. He has used a very wide and flat brush charged with diluted watercolor. The objective was to achieve maximum expression of the contents with a minimum amount of painting.

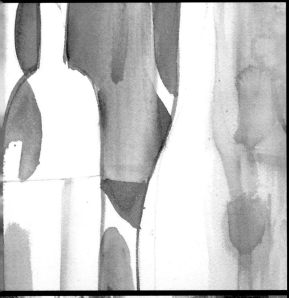

This time, the focus is on the forms of the bottles that are in the background. A large area of paper has been left white to reinforce the idea of light and transparency, thus taking advantage of the light of the support. This way the light is distributed across the entire scene.

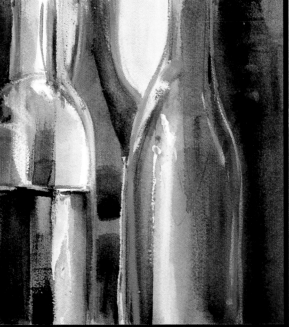

A darker version of the scene required painting the bottles with darker tones. This has created more contrast with a strong chiaroscuro effect, in the Baroque style, which causes the yellow-toned lights and highlights of the front bottles to stand out strongly.

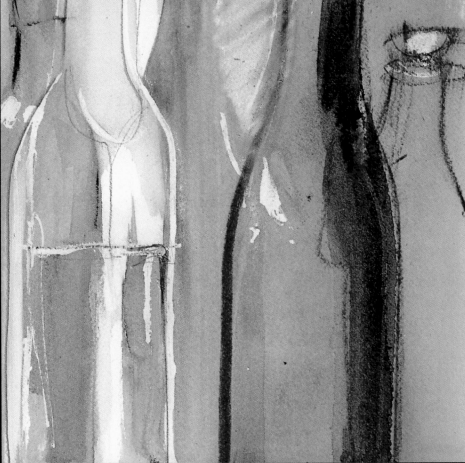

This approach focuses on the cleanliness of the outlines of the forms and the visual tension between the glass and its transparency, the green bottle being very different from the white one.

Window

New Approaches

Other Models

Because the work based on the previous
model was basically focused on transpar-
ency effects, this time the artist has found
an ideal model for studying the effect of
reflections. The windows of an automobile
are a perfect source of images for such
a subject, which is much harder and
more complex. To better understand this
complexity we will show the entire work
process through the final step.

Other Media

Transparent effects can also be created with dry media, such as pencil and pastel, as can be seen in these two works by the same artist. In this case, the applicator and the eraser are used equally for making highlights and drawing light lines. The blending is done with a finger, a cotton ball, or a rag.

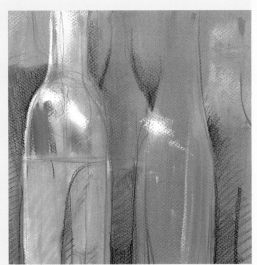

Other Views

Painters from all periods have experienced a fascination with glass, from the beginning of still life painting until the end of the 16th century. These forms are essentially abstract, but until the 20th century painters have not represented them out of context so as not to lose an objective reference. Willem Kalf (1622–1693) unleashes all his artistic potential with an extraordinary virtuosity that could be considered a precursor of the photographic Hyper Realism of Don Eddy.

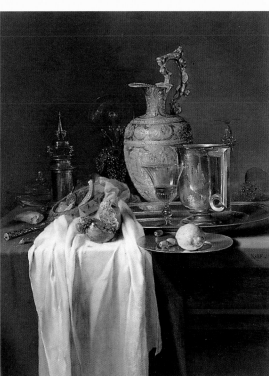

Willem Kalf, *Still Life with Pomegranate,* 1640.
John Paul Getty Museum,
Malibu, California (United States).

Modulated, Textile, and Folded Forms

A second group of characteristic forms is clothing. Folds, tension, knots, wrinkles, swirls, forms of the fabric that express strength or softness, movement or repose, are all created using the line and modeling. Leonardo da Vinci (1452–1519) was one of the first researchers of form. He made numerous studies of all kinds, some of clothing, and analyzed in detail the chiaroscuro in the undulations of the way the fabric hung, its lines of tension, etc. He was a true pioneer in the concept of the art laboratory. He carried out very rigorous studies of form with his analytic attitude and realistic approach, even to the point of proposing inventions that were truly advanced for their imagination and approach.

58

Leonardo da Vinci,
Drapery Study, c. 1472.
Galeria Corsini, Rome.

The Knot: Expression with Wrinkles, Folds, and Tension

In the following creative approach we focus our attention on the folds and tension in a knot. Wrinkles become the narrative theme of the painting and in the visual emotional release. The artist, Esther Olivé de Puig, has treated the composition in a realistic manner, using a classic medium: oil paint, on paper. Although the subject may seem realistic or imitative, the result is daring and fresh, since the brushstrokes are direct, and furthermore, some areas are left incomplete or simply sketched. Clothing studies are usually boring and monotonous; this one, for a change, is very suggestive and dynamic, pulling the viewer into this subject of great conceptual depth and expressive strength.

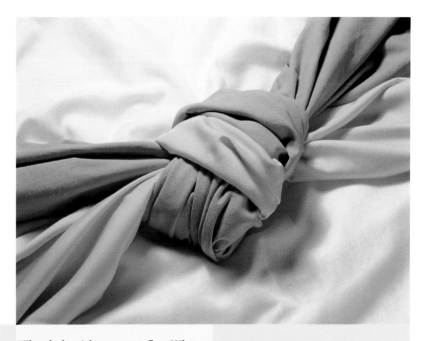

"The cloth wishes to stay flat. When you force it to abandon its flatness because of some fold or flap, observe the nature of the forces there where it has been most wrinkled."
Leonardo da Vinci.

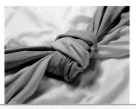

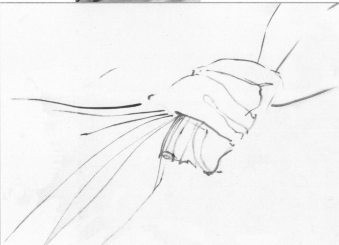

1 We begin by drawing the most essential lines of the knot; those of the outside outline and the inside ones that define the masses and main tensions. We use a fine round brush charged with very diluted paint for this.

2 Next, we adjust the drawing while constructing the form with great accuracy. In this step it is a good idea to define all of the folds and tension to avoid any improvising later. We will construct the model on this drawing.

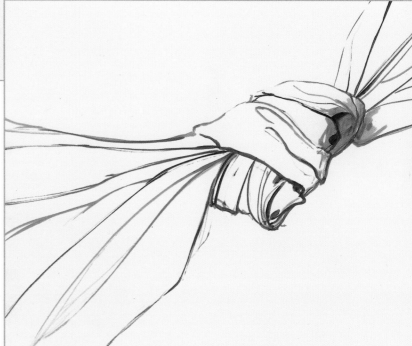

3 The first color is applied with diluted paint, defining the two extreme values of light: light and shadow. It is important to look carefully at the model when creating these volumes and comparatively analyze its chiaroscuro area by area.

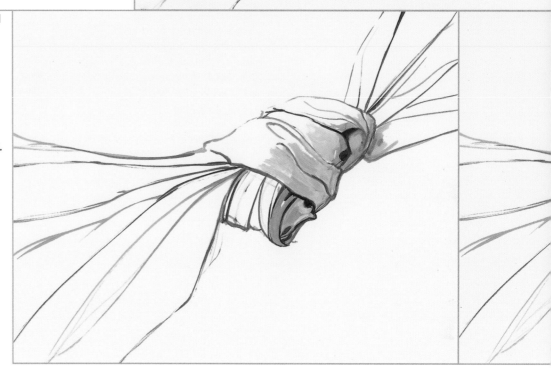

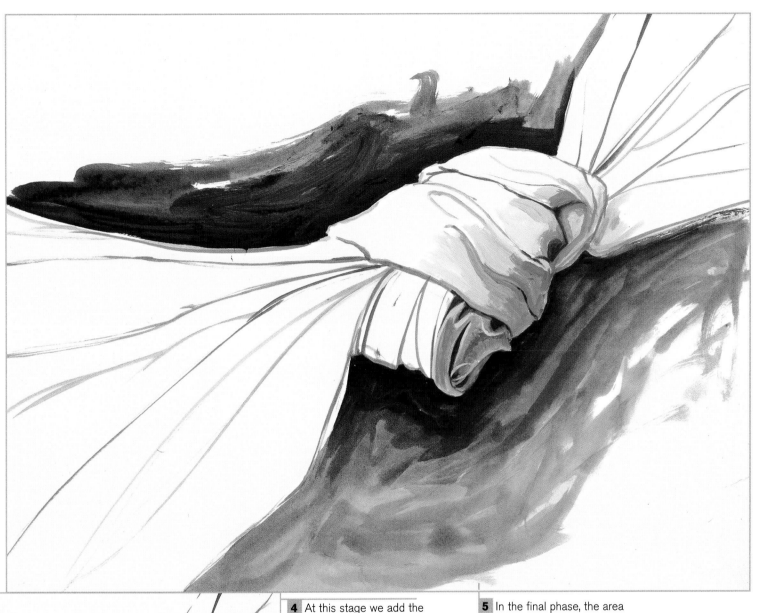

4 At this stage we add the intermediate values of light to lend the modeling greater volume, leaving a large area indicated with only a drawing. This difference in detail causes the viewer to focus on this specific fold defined by the artist.

5 In the final phase, the area surrounding the clothing is painted with a grayer blue tone, using a thicker brush and diluted color. By darkening the background, the figure stands out much more, and the knot becomes more defined. Also, a second contrast is created between the controlled brushwork and modeled, blended paint in the folds of the knot, and the looser, more gestural lines in the background.

Other Versions

A fold, a wrinkle, or a tension will stand out most in the composition according to the approach of the artist. A knot offers a world of modulated forms to be discovered. The author of this approach has focused on different aspects of the same model to develop different themes.

The nucleus of this painting is the subject of the knot itself. By modeling only the central volume and leaving the rest lightly suggested, attention is drawn to the center of the image, where the form is compact and solid.

In this version the artist has worked in detail on the undulating forms that converge at the knot. The final result is an overall triangular form that indicates direction and guides the eye toward the center. The darkened background around the nucleus defines the silhouette of the rest of the subject.

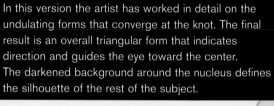

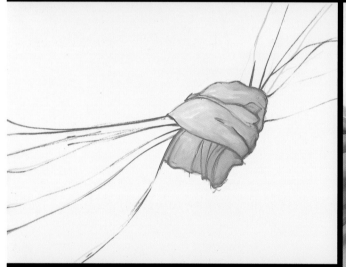

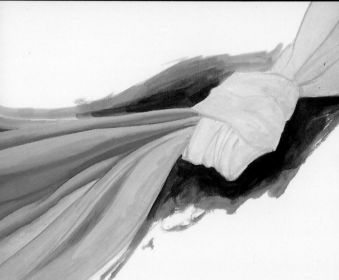

The true subject of this painting is the fold. Reinforcing the lower volume of the knot without completely defining the upper area has succeeded in strengthening the movement of the fabric that is hidden behind the upper folds.

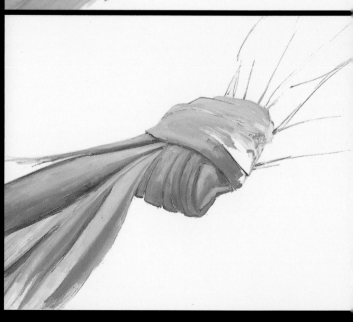

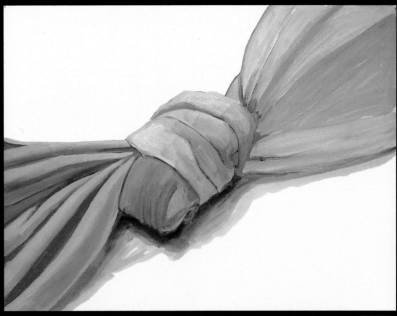

This is the heaviest and most classic version. The shadow projected on the plane of the ground speaks of the mass and weight of the fabric. The heavier impasto treatment with the oils, as well as the very defined chiaroscuro, adds more density to the cloth.

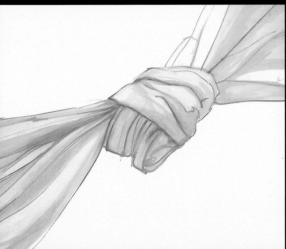

Here the paint has been very diluted to create a soft effect in the forms. This way, the perception of the fabric is more airy and light, since there is less contrast, and the wet on wet mixing achieves a more blended effect.

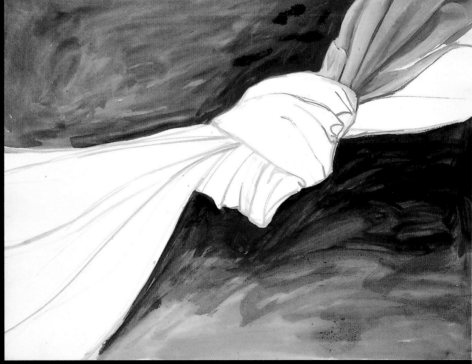

In this composition the artist has worked with the positive and the negative aspects of the knot. By filling in the background and leaving the cloth white the silhouette is enhanced. Detailed modeling of a small part of the fabric shows that it has body and that the fabric is not silk or gauze.

New Approaches

Other Models

Fabric constitutes an array of forms when we consider the weave, the way it is wrinkled or folded, and the light that falls on it. To experiment with a different model without changing the theme, we have hung a knot made with different fabrics. Part of the cloth falls naturally, and the nucleus of the knot takes on a curved form. The resulting form has less tension and seems more airy.

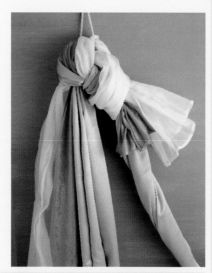

Other Media

This time around, the artist has made different versions with watercolor, a liquid medium that gives fresh and luminous results. The brushstrokes have blended with each other because they were applied wet on wet, producing a very watery effect. The lines were drawn with a fine round brush, varying the amount of paint and modulating the brushstroke to create several widths in a single line.

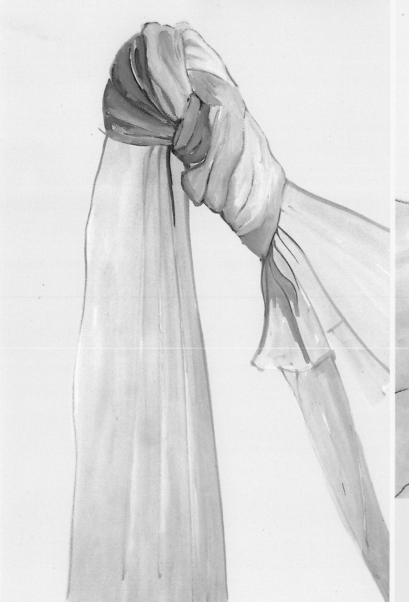

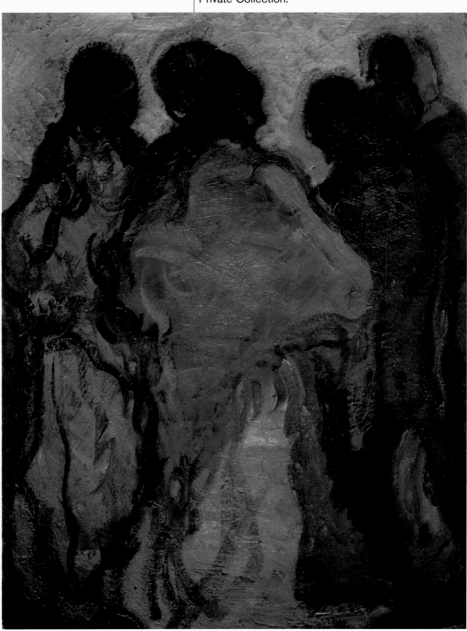

Other Views

Isidre Nonell (1873–1911) painted knots and folds in all of his work. A large part of his work consisted of portraits of women, usually gypsies, who appear in his paintings only partially, many times shrunken or covered with many shawls or veils. The concept of withdrawal encourages looking inward and evokes the solitude of the human being. Therefore, in his work clothing represents an aspect that is as important as the face, because the clothing models the anatomy of these women, wrapping them in a second skin.

Isidre Nonell,
Four Gypsies, 1902.
Private Collection.

Cubist, Angular, and Geometric Forms

Cubism was one of the most unique artistic phenomena of the avant garde in the 20th century. The great contribution of this movement was the appropriation of form and space by the painters, who took control of them and made them subject to the painting's own reality. Juan Gris (1887–1927) understood very well, and demonstrated in his work, that the painting does not have to relate to the subject matter; rather it is the subject matter that must be made to relate to the painting. Of all the many Cubist painters of the time (Picasso, Braque, Léger, etc.), Gris was the one who advanced the ideology the most with simultaneous points of view, several light sources, opening up planes and relief, monochrome tints and color, and painting and collage, in an absolutely free and creative manner. The Cubist forms in his painting become products of his mind and not versions of specific objects, despite the references to reality. This is the purest approach of Cubism.

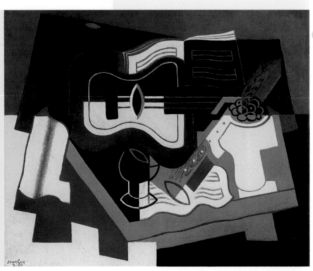

Juan Gris,
Guitar and Clarinet, 1920.
Kunstmuseum, Basil (Switzerland).

A Still Life Composition: Deconstructing a Scene to Create New Forms

We suggest a still life with a complex and heterogeneous arrangement for experimenting with the manipulation of forms following Cubist guidelines. The artist in this approach, Josep Asunción, works at superimposing very different forms. He will begin with the image that results from combining two sketches of the same still life from different, but close, points of view. The medium will be oil paint on a canvas that has been prepared with a base color.

"Cézanne converts a bottle into a cylinder... I make a bottle, a real bottle, beginning with a cylinder. Cézanne works at finding the architecture, I distance myself from it (...) For example, I make a composition in black and white, and then I adjust it until the white has become a piece of paper and the black a shadow."
Juan Gris,
Notes in *L'esprit nouveau,* no. 5,
París, 1921.

1 In the first step, we make two sketches of the same still life from two nearby points of view. They were made with a permanent marker on sheets of acetate, since the transparency of the material will allow the images to be overlaid. The artist will use this final image to decide which lines he wishes to use and which ones to delete so the painting will not be overloaded.

3 Next, we are going to differentiate the new forms that have been created by overlapping the images. The combination of light and dark areas, as well as the areas of different colors, will generate a mosaic of forms that expand and fragment the subject. These areas of color are applied with a brush.

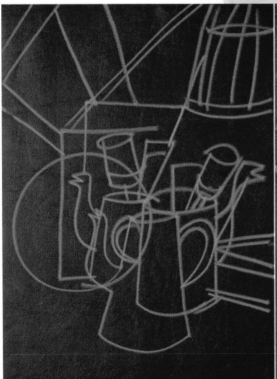

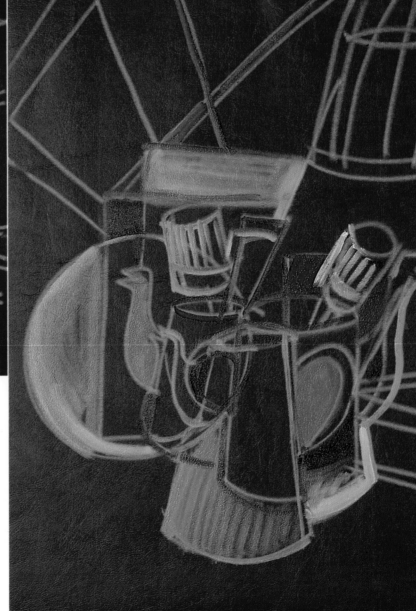

2 This is the finished sketch of the forms. The basic lines, drawn with a light-colored wax crayon, define the general areas. Later new elements will be added if the composition requires them. A willingness to make changes is necessary when making a Cubist painting.

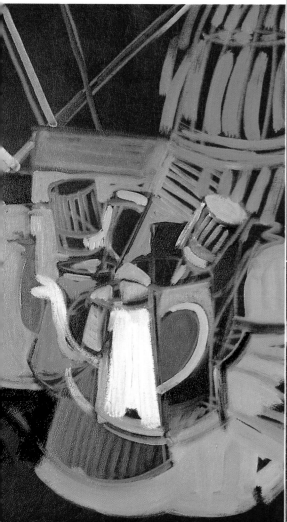

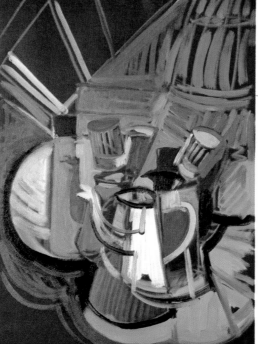

5 In a Cubist painting, contrast is a technique that is used to create dynamism and add richness to the composition of the forms. Therefore, in this step we have used new colors and chiaroscuro.

4 Color is built up little by little to give the painting more body. More color tones and light are also incorporated into the background. It is not an empty space, but a group of complex forms equal in importance to the rest, since we are not making a composition with a central subject.

6 Before the painting can be considered finished, the brown tones of the background are brought out, and wide brushstroke lines of oil paint are applied over areas of flat color.

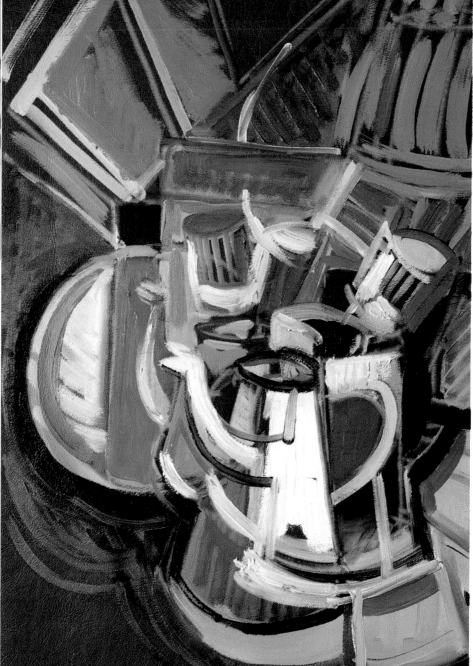

Other Versions

The main characteristic of Cubist forms is ambiguity. A Cubist still life always creates a strange first impression because of its lack of logic, since each form penetrates into the one next to it or shows a side that would be hidden from that point of view. In each of the following paintings the artist has created a separate universe of interwoven forms.

In this still life the artist has decided to make the elements of the background stand out more but without completely defining them, converting the volumes into unfinished planes. He has done this by hatching with parallel brushstrokes in a restricted range of colors.

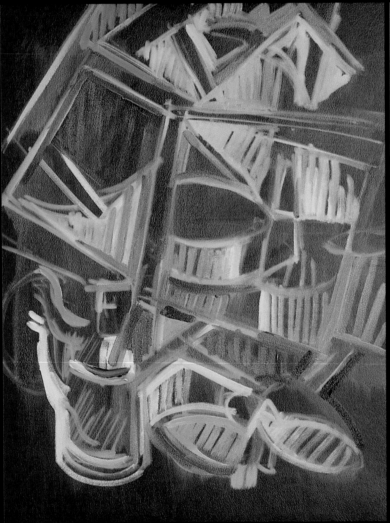

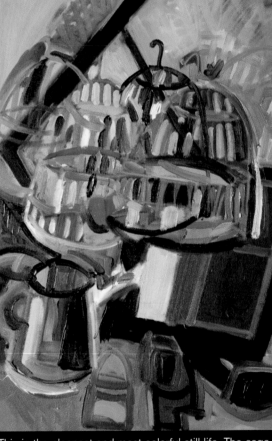

This is the cleanest and most colorful still life. The cage and the apple are the center of attention, and stand out because of their bright red color. The lines of the three views of the cage are not excessively overworked, which gives the painting a slightly relaxed feeling.

The colors of this still life have become quite muddied from the heavy and quick brushstrokes that were used to exaggerate the sense of chaos caused by the juxtaposition of images. The forms seem torn and fragmented. Making the apple stand out is a trick used to move the viewer's eye with a certain amount of control.

The parallel line hatching applied over the flat colors at different angles enriches the composition of this painting. When it comes to the form, the artist has opted for it to be ambiguous, so that it comes very close to being abstract.

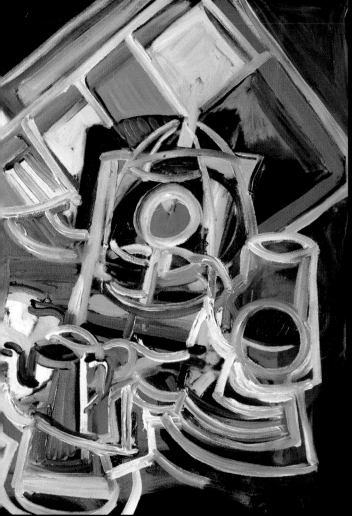

This painting shows a taste for contorted forms. The artist has enclosed all the forms with a thick and energetic brushstroke, interweaving them with each other in a large compact, yet transparent, mass.

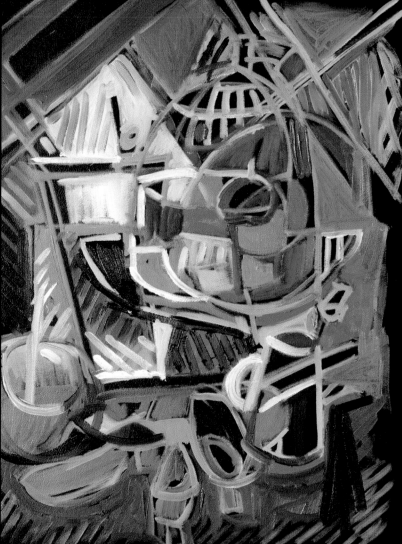

New Approaches

Other Models

Geometric shapes are not lacking in Cubist still lifes. This is either because they are the starting points for other specific forms, or because they are the result of synthesizing the model. In this case, the painter has arranged a still life with a very geometric structure: cubes, cylinders, and a large circle are composed in the shape of a pyramid. The resulting composition is more ordered, and the forms are flatter and more angular.

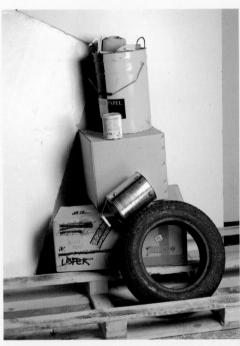

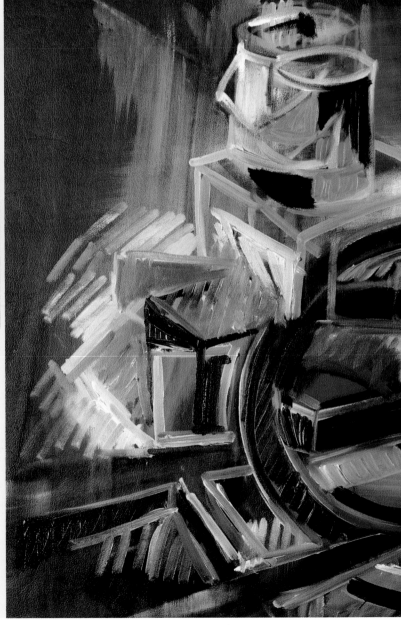

Other Media

We have decided to use a dry color medium, pastel, to create artistic effects that are different from those of oils. This medium can be used to combine soft blending and clear, distinct lines. As can be seen in this pastel, the result is more atmospheric and airy, which reduces the density and body of the forms.

Other Views

Georges Braque (1882–1963) was one of the major figures of Cubism. His focus was very different from that of Juan Gris. Braque was interested in discovering the forms of space, rather than the forms of objects, reformulating them and giving them substance. He said, "There is a tactile space in nature, a space that can almost be defined as manual...what attracted me most, and furthermore, was the main guideline of Cubism, was the materialization of this new space that I perceived. I could not introduce the object without having first created the space in the painting."

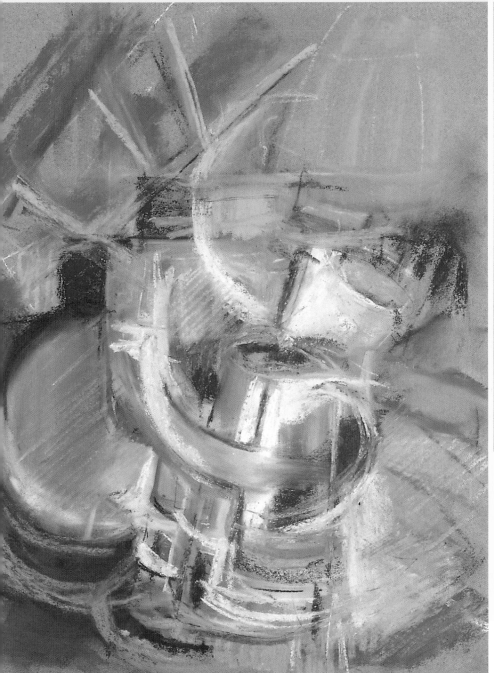

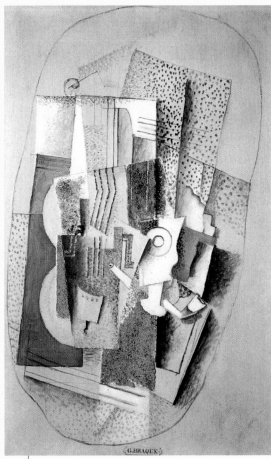

Georges Braque,
Music.
The Phillips Collection,
Washington, D.C. (United States).

Flat, Architectural, and Irregular Forms

Many of the forms in still life paintings have geometric structures with parallel planes: tables, chairs, mirrors, etc. Painting interiors is one category of still life where the field of vision is reduced and the objects become an important component. Egon Schiele (1890–1918) painted a beautiful picture of his bedroom, inspired by Van Gogh's bedroom in Arles, but he used a very different treatment for the forms. Just as he did in his urban landscape painting, Schiele eliminated the perspective, changing the volumetric forms into flat surfaces. The space of the bedroom, along with its furniture, is thus converted into a group of perfectly harmonious flat and square forms.

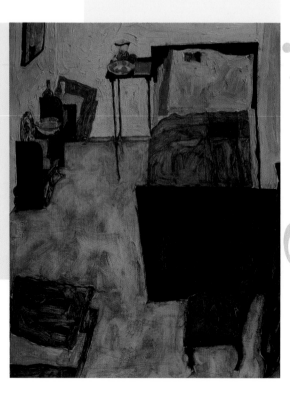

Egon Schiele,
The Artist's Bedroom
in Neulenbach, 1911.
Historisches Museum der
Stadt Wien. Vienna (Austria).

The Room: Discovering the Forms of Interior Spaces

To conclude the series of approaches to the still life genre, we will focus on experimenting with flat forms. To do this, the artist for this project, Josep Asunción, begins with a conventional interior space, a modern office with a clear orthogonal structure. The primary medium used is acrylic paint applied to paper with a brush and a sponge, and finished with hard pastels. Using the structure of the space and furniture as a starting point, the artist will begin defining new forms born of the dialogue between the occupied space and the empty space.

"Soon some people recognized that they were seeing objects in the interior and they did not ask any more questions."
Egon Schiele, 1911.

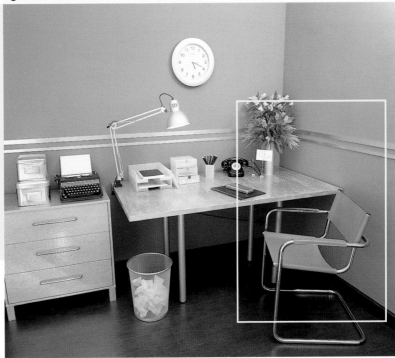

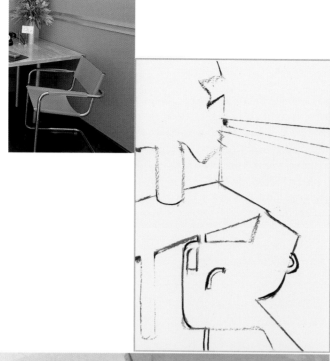

1 We lay out the spatial structure with charcoal, changing it into separate flat forms. The openings in the chair combine with the tubes and planes to create a form that contains positive and negative spaces in a new combination.

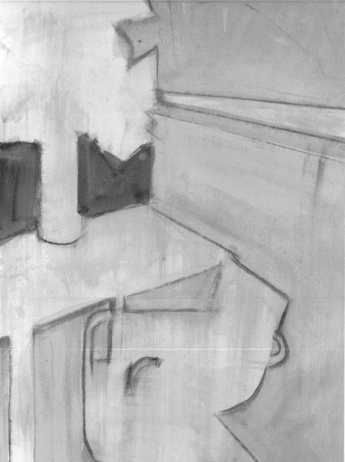

2 The first diluted acrylic colors are applied with a wide, flat brush to define the general planes of the painting. Successive layers will be applied over these colors to define the surfaces.

3 We wipe a moist sponge across the color, rubbing it to create a greater atmospheric feeling and to lighten the tones. Then a second layer of white is applied to the chair, and brown to the surrounding space.

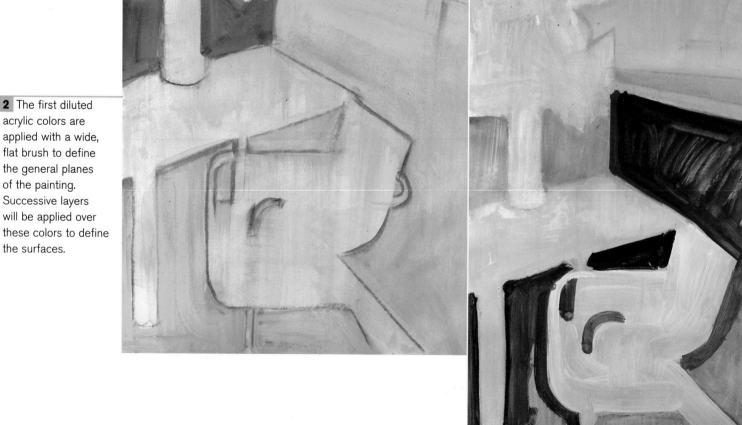

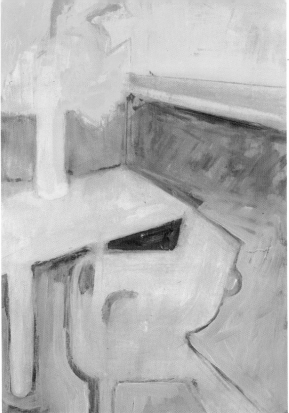

5 Finally, we apply the last layer of paint, allowing some of the previous layers to show through. This results in surfaces that are not cold and direct, but sensitive and textured, yet flat.

6 The painting is completed with an application of black and white hard pastels that redefine the outlines of the forms and visually vibrate against the soft color on the planes.

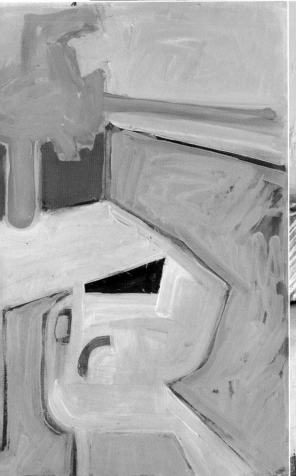

4 Successive layers of alternating lights and darks are intuitively applied over the existing tones, until the artist creates a balanced contrast between the intensity of the colors of the forms.

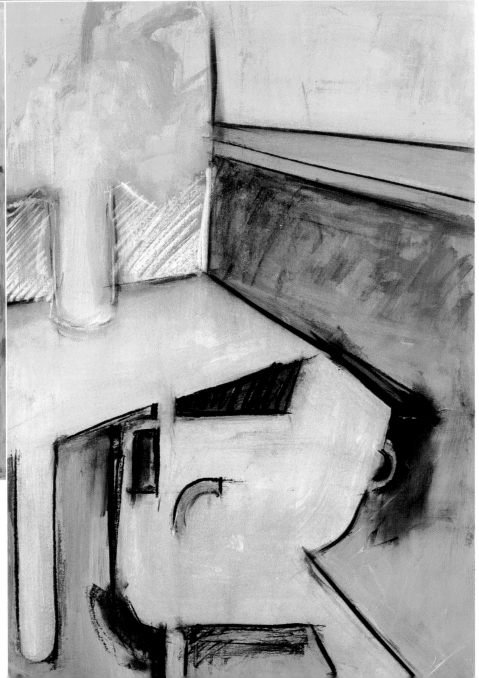

Other Versions

The creative highlight in this approach is in the multiple combinations of forms found in the dialogue between full and empty, positive and negative. The author has experimented with the relationship between the forms in these four paintings, while working to create new forms derived from these relationships.

The forms of the shadows projected by the table and chair are emphasized in this work. Their trapezoidal structures combine with the planes of the furniture, which are highly illuminated to create a harmonious dialogue of forms. The painting was done entirely in acrylic applied with a brush.

This work is more austere in color and composition, but rich in artistic qualities as a result of combining acrylics applied with a sponge and brush, and then charcoal. It creates mass in the empty spaces and empty space in the furniture.

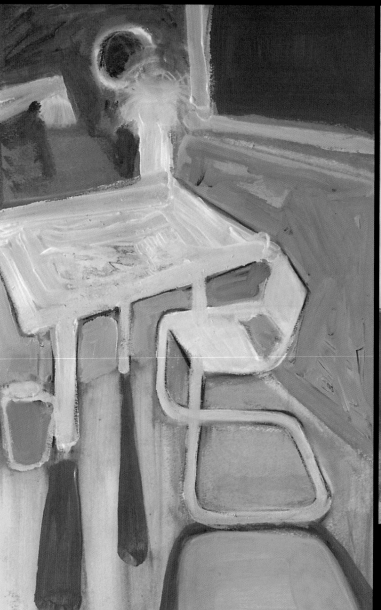

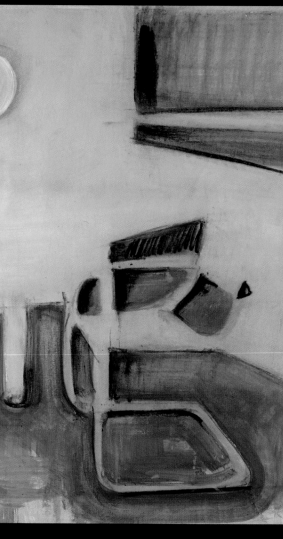

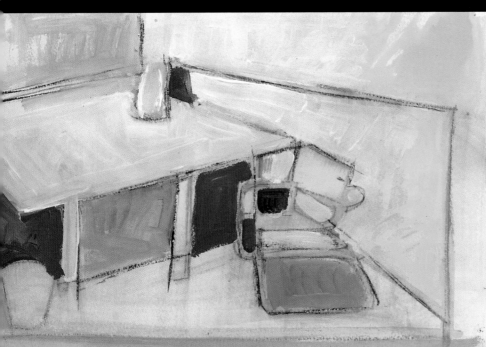

This work is very balanced in terms of the empty and full spaces. Its uniqueness lies in the use of flat forms within an organized structure that defines the picture plane.

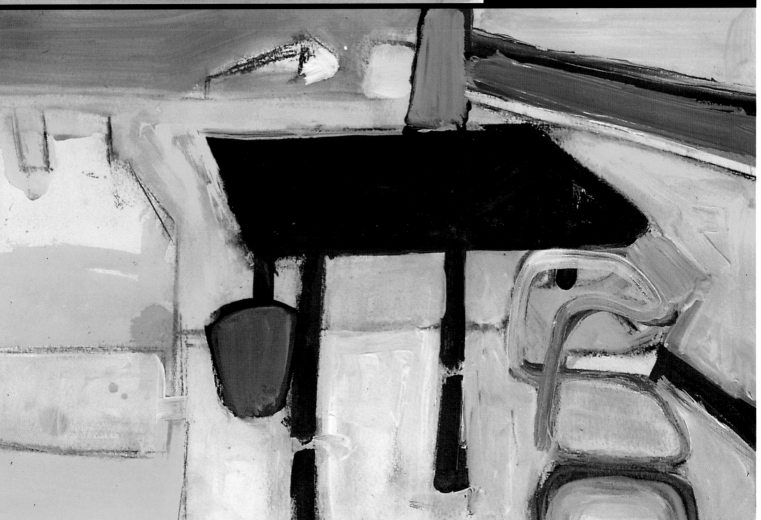

The weight of this composition lies in the dark mass of the table, which is visually connected to the wastebasket and the vase, forms that are reduced to simple green planes that are very irregular and contorted. The floor appears very dense because of the heavy application of acrylic paint.

Other Models

Wishing to vary the structure of the form, the artist has worked creatively in another interior environment, a dining room. The elevated point of view and the proximity of the table deforms the objects, making them more dynamic, and introduces an ellipse into the central plane of the painting. The tension between the heavy masses and the light forms is exaggerated to create greater ambiguity and enigma.

Other Media

Here the artist wanted to experiment with very direct techniques like pastel, charcoal, and marker on handmade colored paper. In all three cases the line and the plane have been treated in a synthetic and structural manner.

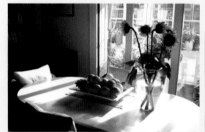

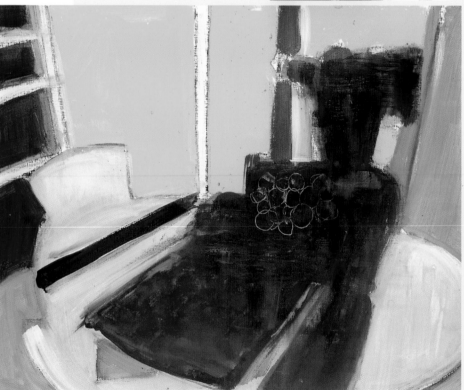

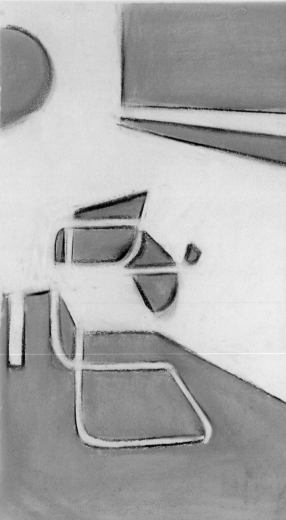

Other Views

A 20th-century painter who often worked with the forms of interior spaces was Edward Hopper (1882–1967). His work was mainly inspired by light, which defines form and space. Projected shadows create incredible forms that fill the space without occupying it. The result is clean and clear, highly defined, and of great beauty because of the simplicity of the subject and the value of the empty spaces. Space and light aquire form in his work.

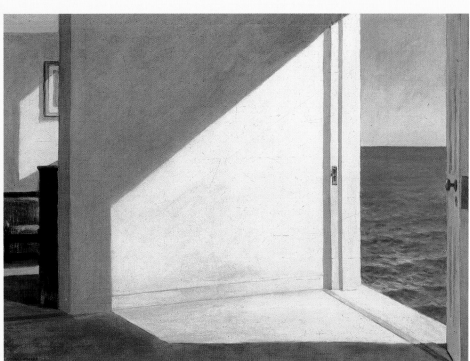

Edward Hopper,
Rooms at the Ocean, 1951.
Yale University Art Gallery,
New Haven, Connecticut (United States).

Three great traditional themes exist within the landscape genre: landscapes, seascapes, and skyscapes. Each one of these focuses on different forms: spatial and defined forms in landscapes, weightless and atmospheric forms in skyscapes, and liquid forms in seascapes. This chapter offers creative approaches for each one of them.

Form in

the Landscape

"(...) I will add that nature should not be copied too faithfully (...) a simple copyist can never produce anything grandiose."
Sir Joshua Reynolds,
Fifteen Discourses, 1790.

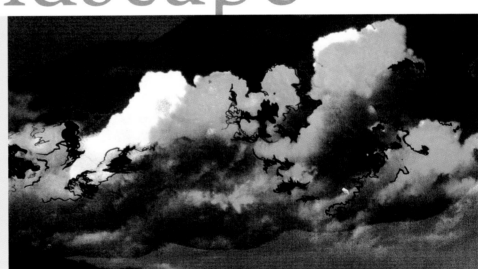

Atmospheric, Weightless, and Blurred Forms

The sky is the source of the light that defines the landscape; therefore it has always held a special fascination for landscape painters. Alfred Sisely (1839–1899) said in an interview in 1892, "It cannot be that the sky is merely a background…I emphasize that particular part of the landscape because I want you to understand the importance that it has for me… I always begin a painting with the sky." But some painters went even further than Sisely. John Constable (1776–1837), predating Sisely and precursor to the Impressionists and the Barbizon School, had already fixed his gaze on the sky and made many studies of clouds, amazed by their illuminated and illuminating forms. He was one of the first painters to go outdoors and paint in the open air to capture a true impression of nature, especially when it came to light. He revamped the techniques for constructing a painting, abandoning the brownish underpainting that darkened and idealized the landscape. His vision was a reaction against the Industrial Revolution, and he followed it by opening windows to nature.

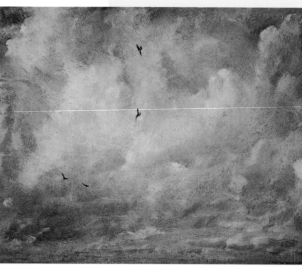

John Constable,
Stratocumulus, c. 1821.
Yale Center for British Art,
New Haven, Connecticut
(United States).

The Sky: Experimenting with a Spectacle of Changing Forms

This time we propose casting a glance at the sky and capturing the spectacle of changing forms present in the banks of clouds. We are going to paint a cloud study like Constable did on so many occasions, although we will take the liberty of making much more modern personal additions to the forms. We will start with the classic cottony clouds, with light, weightless, and ethereal yet dense and contrasting forms. Unlike Constable, the artist for this exercise, Gemma Guasch, decided not to work outdoors but in the studio. She used a mixed technique that included inks, acrylics, and a transfer of a photocopied image. Beginning with the transfer of the image, the artist added materials, using a variety of working tools and criteria. The result is a rich and varied gallery of suggestive and changing images, similar to what is seen when looking at the sky.

"When the heavy clouds appear, filled with storms, the weak spirits on the plains are frightened, but for the strong they are always a powerful experience because of their grandiose drama."
Emil Nolde,
Autobiography, *A Stay on Alsen Island,* Denmark, 1910.

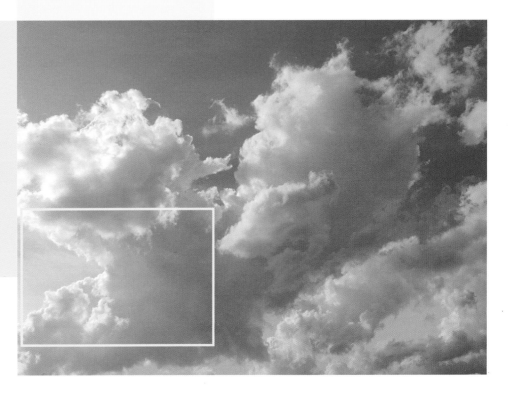

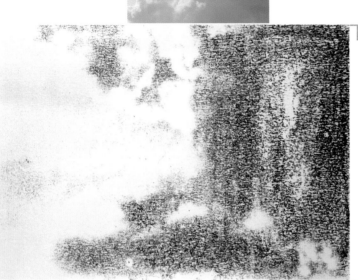

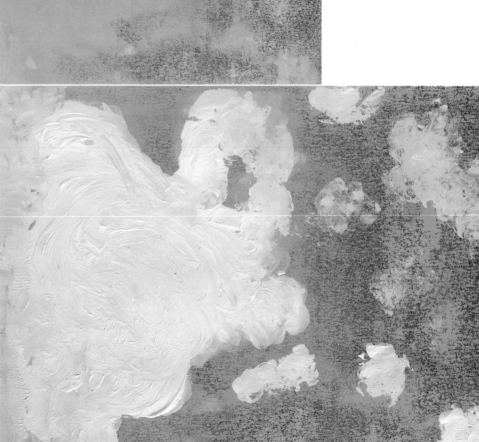

1 Starting with a photocopy of an enlarged detail of a photograph of the sky, new atmospheric forms will be generated. The first step is to transfer the image by rubbing the back of the paper with a cotton ball moistened with solvent. The transferred image will just be the starting point, the first markings, but later they will almost completely disappear. Notice that the transfer reverses the image.

2 Next, a layer of color is applied by lightly wiping with a sponge moistened with orange ink to create a unified color and a bright atmospheric background.

3 The first brushstrokes for the clouds are applied with cotton and with the fingers, building up the white paint. This manner of painting gives the artist a better tactile sense of the atmospheric sensation of soft and weightless form.

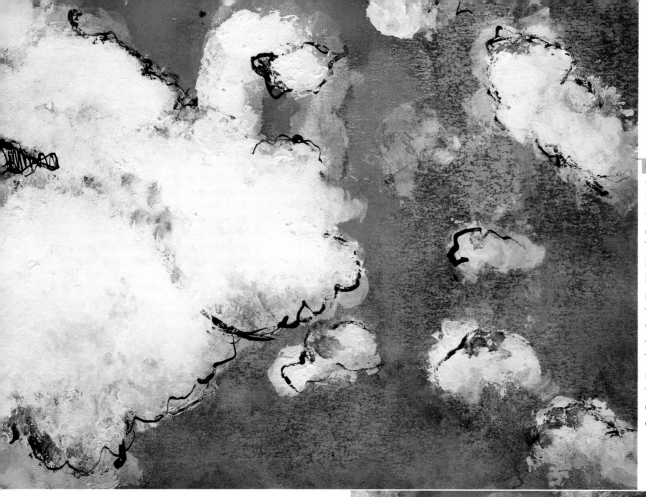

6 Finally, the initial whites are brought back, although this time with greater density and ambiguity. The sense of weightlessness, created by lightly applying the paint with cotton, was the feeling the artist wished to convey in this study of form. The new lines suggest changes of form and space that enrich the visual experience.

4 Some forms are detailed with india ink applied with a reed pen to create clear boundaries and reinforce the changes of rhythm of the large masses. The clouds are not outlined, since that would mean isolating them and ruining their feeling of weightlessness.

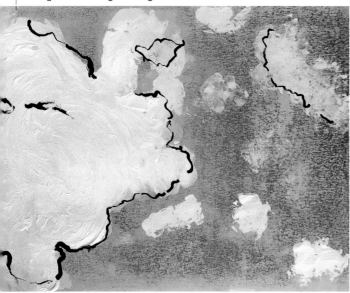

5 Then, a wash of very diluted blue acrylic paint is applied with a sponge, helping to neutralize the color of the atmosphere and creating a contrasting vibration in some areas.

Other Versions

The main characteristic of atmospheric forms is that they are always changing. Clouds are often very contrasting, or soft and delicate. They also take on interesting forms that can sometimes be totally confused and ambiguous and at other times are identifiable as narrative and fantastic images. Working with cloud forms can greatly develop creativity and help achieve a large number of results, like the ones shown here, all by the same artist and made using the same techniques: transfer, inks, and acrylics.

The artist has used a large amount of water to paint these clouds that explore the confusion between space and volume. Some more viscous and undefined forms, even chaotic in certain areas, create the sense of a turbulent and stormy atmosphere.

The silhouettes and empty spaces of the form have been emphasized with hatch lines of india ink applied with a nib pen, evoking an Oriental skyscape.

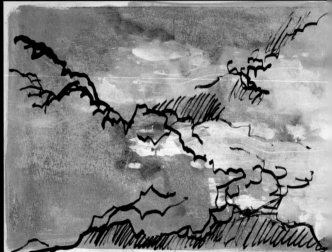

The lightly worked image and the focus on the white of the weightless mass have created pure and tangible forms, similar to those seen in the sky when traveling by airplane.

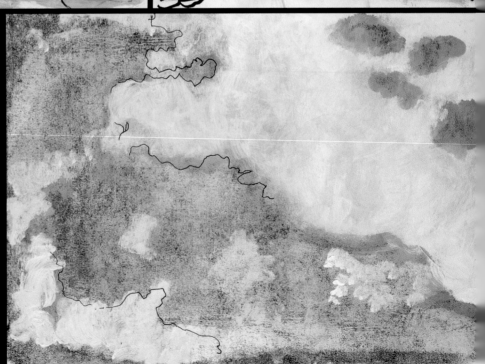

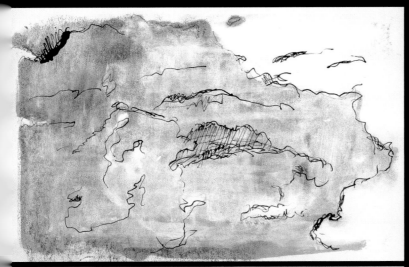

The remains of a cloud that is no longer there evoke the ephemeral character of clouds, which soon dissolve and whose forms disappear only to reappear with a new shape.

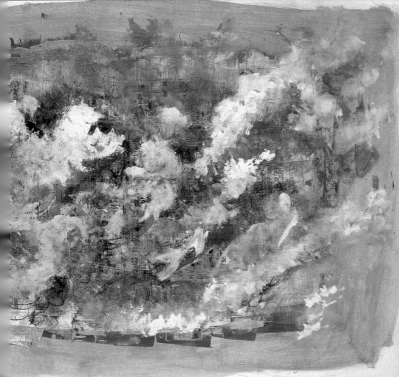

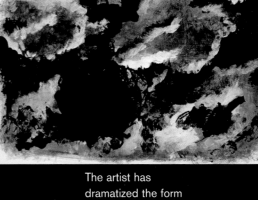

The artist has dramatized the form by using strong contrasts, making them vibrate, and even creating a feeling of sound, like in a storm where the skies roar. Here form is imposing and majestic.

Heavy applications of paint strengthen the light that is created inside the forms of the cloud; forms inside forms, spaces with form.

Window

New Approaches

Other Models

Each sky conveys a different mood. A blue sky with white and weightless clouds encourages optimism; on the other hand, a sky like the one selected as an alternative to the first one provokes melancholy. Whenever the sky is painted with a low sun, the clouds are brightly illuminated, their forms dramatized, unlike the midday skies that light them from above. In this new approach, the artist developed a dramatic and melancholy form, giving it a foggy effect created by layering the paint.

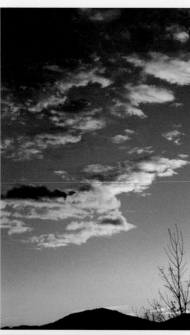

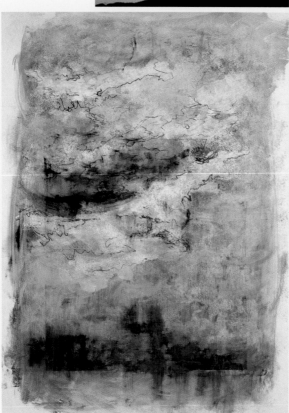

Other Media

It is also possible to develop cloud studies using techniques that are more graphic and less painterly. Exploring technical variations, the artist made a pencil drawing using cross-hatching in which the silhouettes stand out, another pen and ink drawing that strengthens the vibrant lines, and last, a photocopy painted with colored ink and india ink line work.

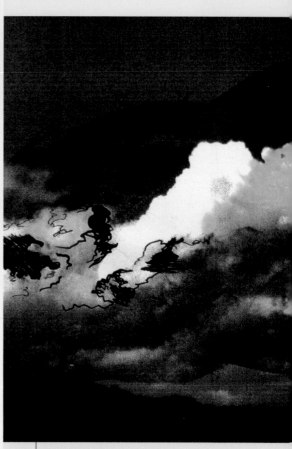

Photocopy and ink

India ink

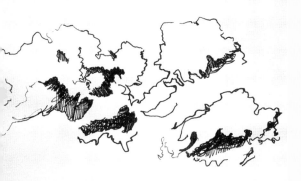

Other Views

To illustrate cloud studies from the viewpoints of other contemporary artists, we will look at two very interesting different approaches. Henry Moore (1898–1986), who had a very sculptural vision of form, treats the subject of clouds by reinforcing their relief and masses in a drawing made with charcoal, pastel wash, watercolor, and black ballpoint pen. Fernando Zóbel (1924–1984), an abstract painter especially interested in light and the ephemeral images it creates, gives us an atmospheric theme in oils that is more ambiguous and ethereal, yet ordered and clean. According to Zóbel, it is necessary to empty oneself to become filled with the landscape, and this spiritual attitude allows the pure and ethereal forms to emerge.

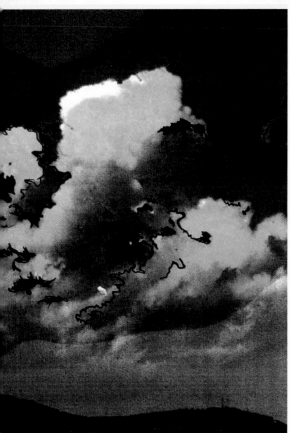

Fernando Zóbel,
The Seagull, 1982.
Museo de arte abstracto
español. Cuenca (Spain).

Henry Moore,
Landscape of a Mountain with Clouds, 1982.
The Henry Moore Foundation, Perry Green.
Hertfordshire (United Kingdom).

Pencil

Spatial, Juxtaposed, and Divided Forms

The structure of a landscape is determined by perspective, because it is essentially a painting of space, not of form. But this does not mean that in a landscape there are no forms to discover and work with—the forms of open space. Paul Klee (1879–1940), affiliated with the German Expressionist group "Der Blaue Reiter" (The Blue Rider), was a painter with a very personal language who never attempted to reproduce or imitate the forms of nature. Rather, he expressed himself with symbols that would suggest the gestation of forms. This explains his admiration for the artistic work of children and primitive peoples. He never made a distinction between the real and the imaginary, between the exterior and the interior, since these are not opposite concepts but form a single unity: the cosmos. This is why his work falls between being abstract and figurative. Landscape was one of his favorite painting subjects because of the connection it established between man and nature and because it is an environment that promotes new forms based on this connection.

Paul Klee,
The Crossing Guard's Garden, 1934.
Gallery K.AG. Basel (Switzerland).

Panoramic Mountain View: Defining Forms in a Deep Space

In the following exercise, we propose converting the spatial structure of a mountain landscape, which has aerial perspective, into divided and juxtaposed flat forms, like in a stained glass window. Converting three dimensions to two offers an opportunity to create new forms that individually mean little, but grouped together make an image, like a completed puzzle. The artist for this exercise, Josep Asunción, has chosen collage as the ideal medium, since it allows him to work directly with flat cutouts. The materials he uses are cellophane and tissue paper, for their transparency, and wax crayons for drawing lines.

"I work like a gardener or a grape grower. Things come slowly. My vocabulary of forms, for example, was not discovered all at once. It has grown almost in spite of me."

Joan Miró,
1959.

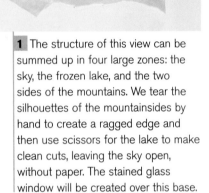

1 The structure of this view can be summed up in four large zones: the sky, the frozen lake, and the two sides of the mountains. We tear the silhouettes of the mountainsides by hand to create a ragged edge and then use scissors for the lake to make clean cuts, leaving the sky open, without paper. The stained glass window will be created over this base.

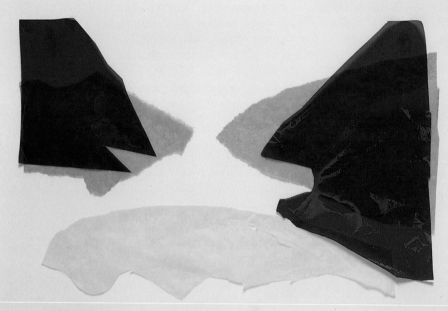

2 Two pieces of darker blue are added to both sides of the lake to create the foreground. They are cut irregularly so the paper behind them can be seen around the edges. Although the composition has a central axis (the lake) the mountains are not symmetrical, making the forms more natural.

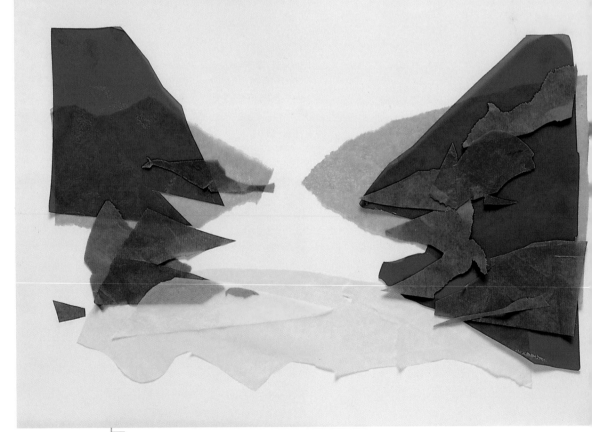

3 We must think ahead in this phase. Pieces of warm-color paper are added that will be covered in the following steps to make different tones of blue and that will define the shadows of the rocks and the inside of the lake.

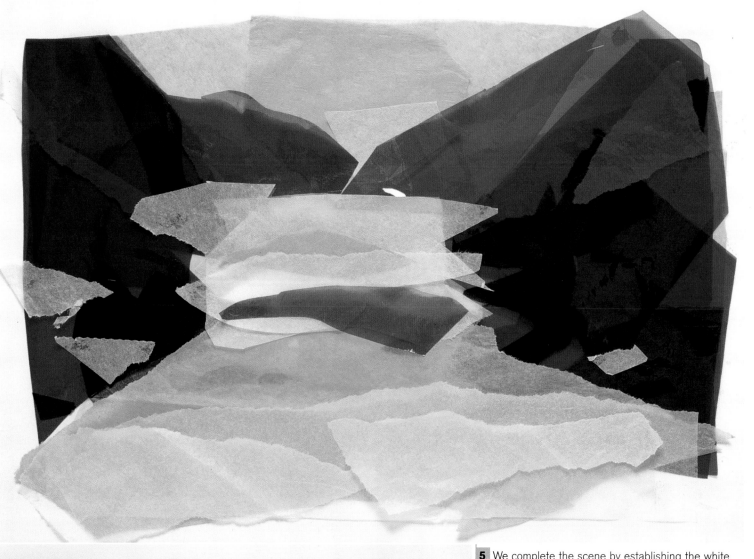

5 We complete the scene by establishing the white areas. White should be applied at the end, since it defines the skin of this landscape: the snow. The result is a puzzle of flat forms that are integrated through transparency, like a stained glass window.

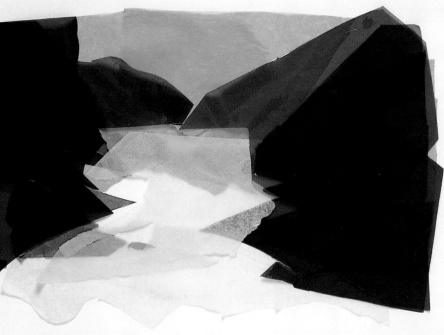

4 Next, we define the masses by giving the landscape body and density. To do this we cover the warm tones of the lake and the mountainsides, and we fill the sky with areas of blue.

Other Versions

The variations that can be used in a creative approach of this type are the form of the cutout, the number of papers that are used, and the style of the outline. In the following five landscapes the artist has applied these factors in different ways, experimenting with them creatively.

It is possible to express the forms of a landscape with only a few elements. Large masses create atmosphere and add light. The simplicity and scarcity of detail is the perfect road to visual poetry.

The increasing and decreasing rhythm produced by the sequence of forms is the focal point of the visual conversation in this collage. Using fragments of tissue paper cut out with scissors to create clean and angular edges, the artist has taken advantage of the triangle shape to increase the compositional tension and the dynamism.

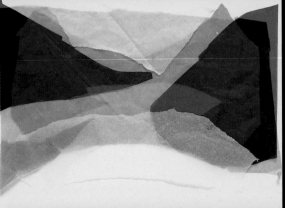

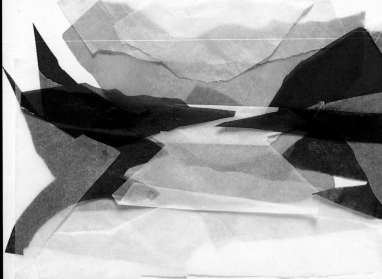

The crisscross structure of this landscape is reinforced by the shape created between the two mountains. This form evokes a greater sense of distance by emphasizing the horizon. Another unique aspect of this collage is the fact that it is not enclosed in a graphic frame. The white of the paper partially encroaches on the interior of the landscape.

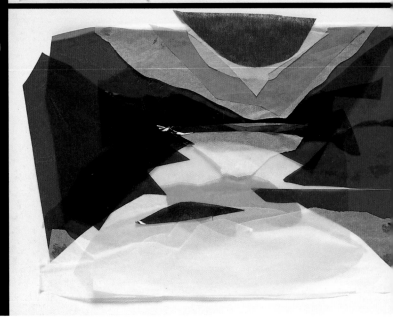

This is the collage that comes closest to the idea of a stained glass window. The outlines on the pieces of paper look like the leading used to make the windows. The lines have been drawn with a black wax crayon. The forms take on a rhythm created by the predominantly horizontal strips.

The forms in this landscape are a result of a free combination of lines and areas of color. The lines are not limited to the silhouette's outline, but also cross over them to create new forms that divide the planes. This is the freest and most creative image of the five shown in this gallery.

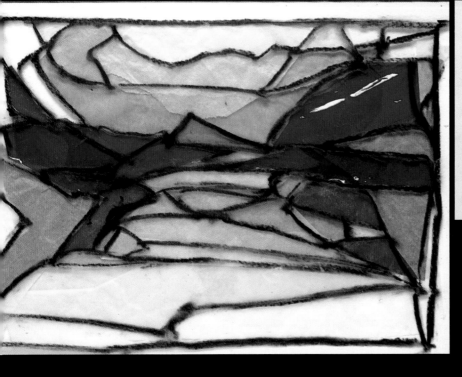

New Approaches

Other Models

Light and atmosphere is what the artist has expressed in this new, much warmer landscape. He has used superimposed colors, taking advantage of their transparency to create ethereal and misty forms, those of air and light. To increase the soft effect the artist has used little contrast between the forms.

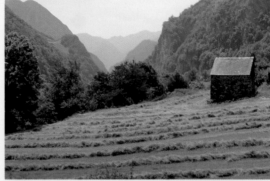

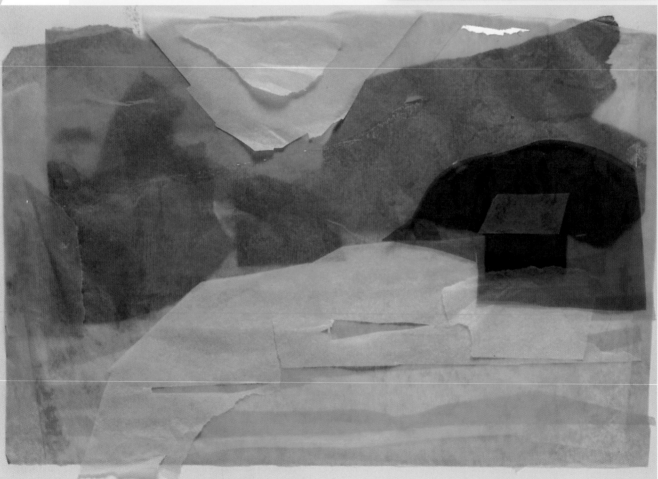

Acrylic

Other Media

The painter has resorted to the use of acrylics and wax crayons to employ more painterly techniques like impasto, brushstrokes, or hatching. In the first case the results are dense and creamy, the buttery forms suggesting a soft landscape. The line is harder and more vigorous in the wax crayon landscape; here the forms acquire texture and reproduce the tactile feeling of the landscape.

Other Views

Another approach to the task of synthesizing space is to convert it into an image that is more like tile mosaic than a stained glass window. Vladimir Dimitrov Maistora (1882–1960) has met this challenge by applying hatching, a more graphic technique, typical of line drawings. By varying only the distance between the lines and their direction it is possible to create a sense of space. Each one of the hatch areas is like a tile in a mosaic, and has no meaning if separated from the whole.

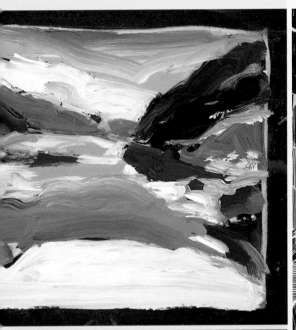

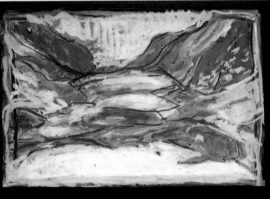

Wax crayons

Vladimir Dimitrov Maistora,
Balloons, 1927.

Liquid, Aqueous, and Flowing Forms

There is something very characteristic of river scenes and waterscapes: the liquid forms. Water is an unending source of forms. Changing and dynamic, flowing forms are arranged as longer or shorter streams or in bands that always follow a rhythm, that of the movement of the water carried by the current. David Hockney (born 1937) is one of the contemporary visual artists who has most extensively depicted the subject of water, in his famous series of swimming pool paintings. His Pop Art style is clearly influenced by Matisse and Picasso and contains a strong charge of humor and eroticism. A very pure treatment of form, based on flat colors and hard edges, turns his pools into icons that relate to the concept of well-being, through the fresh and luminous effect of the water.

David Hockney
California, 1965.
Private Collection.

The Sea, Source of Forms: Creating Based on Its Magic

Finishing the chapter dedicated to form in the landscape, we suggest a creative approach based on the movement of water. The artist, Gemma Guasch, has chosen a maritime model where the water assumes serpentine and lively forms. The medium that she uses is oils with a canvas panel for the support. It is possible to create impasto and washes with oils, and they also can be mixed directly on the painting, which helps represent the water.

"The water was rough, our boat was small. My (wife) Ada was seasick on deck, tied to the post. 'The sea is so beautiful,' she said, 'so powerful, so grandiose!,' she exclaimed...I was near her, convulsively grasping the stair rail, looking, amazed, and rocking back and forth with the waves. So intensely...

"That day is so etched in my memory that years later I painted my seascapes based on this model: the images with green waves, fierce and agitated, and just in the upper margin a little yellowish sky. If the sea had washed me off the deck, if I had had to struggle with the liquid element between life and death, would I perhaps be able to paint the sea in even more impressive conditions?"

Emil Nolde,
Autobiography, *A Stay on Alsen Island,*
Denmark, 1910.

1 We create the base color with a stiff oil brush, applying a series of horizontal bands drawn loosely with a rhythmic motion.

2 Next, we apply a second layer of darker blue to give the mass of the water more density. Then we create lines by scraping with a spatula to reveal the support and define the forms in the moving water.

3 Using short, curved brushstrokes we apply the middle values of the light. These begin to create undulations in the water and give it a sense of surface.

4 To create more relief in the forms we introduce the darkest tone of blue, which contrasts with the previous colors to increase the depth of the water and indicate the existence of reflections.

5 The final touches of light with bluish white add weightlessness to the water and a sense of motion. The idea of fluidity is depicted well since the paint is thick and the colors are mixed on the support.

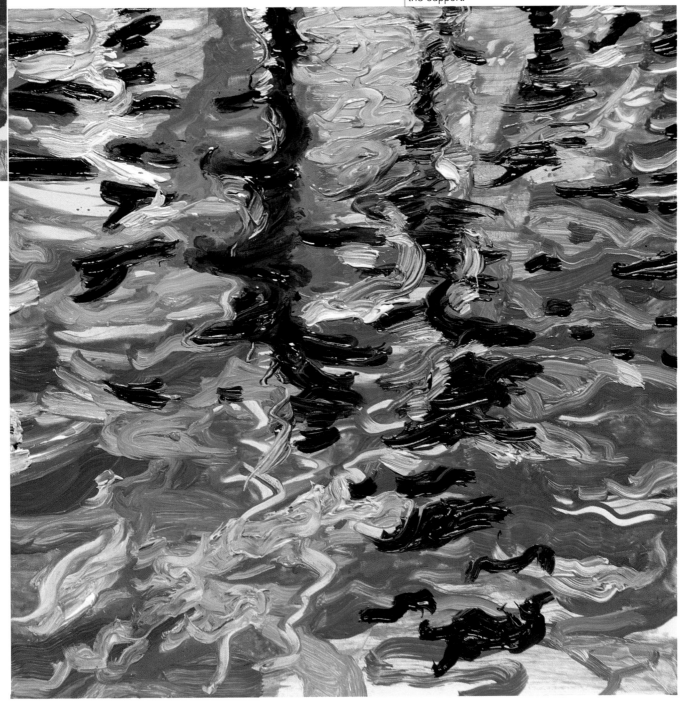

Other Versions

We can focus on several aspects of the many forms that water takes: the lines of its currents, its highlights, and its relief. In any case, there is always ample creative room for making more or less complex, but changing, forms. The artist has experimented with five different effects of the water, as shown in this gallery.

Large areas in the form of dark vertical strips give the sea mass and help focus the eye on the capricious forms in the foreground that express the movement of the waves.

This composition is very unique. In it the artist has had fun with the circular forms of the highlights, drawn with a brush and scraped with a spatula.

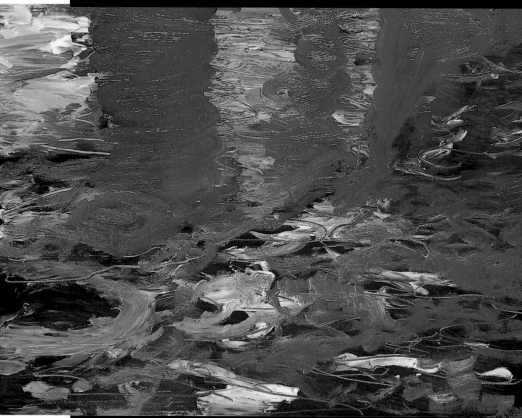

Serpentine forms are a characteristic of water. To greatly simplify the forms only two tones of blue have been used, applied with very few brushstrokes. A few broken lines have been made with a spatula to express the forms of the highlights.

In this painting the spiky shapes in the water stand out among the crests of the waves. These are spaces that take form and add relief to the surface.

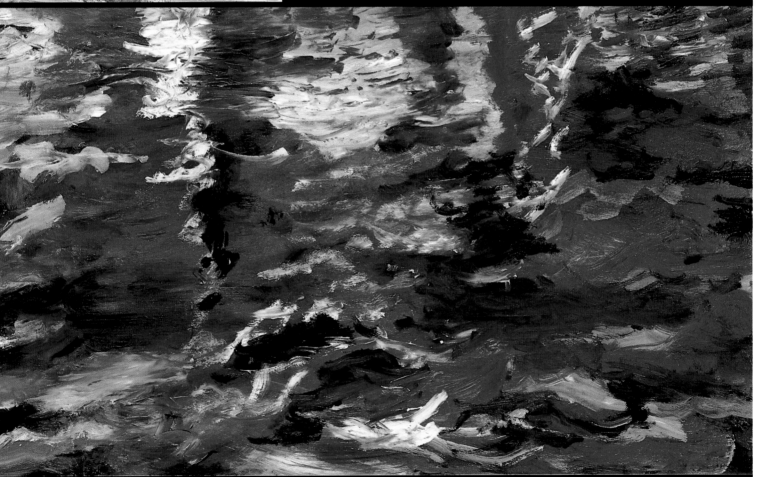

This is a more horizontal approach, which makes the most of the forms of the waves. Modeled zigzag undulations have been created with loose brushstrokes. This is the form that water takes in a moving sea.

New Approaches

Other Models

One detail of the water can take us to the purest abstraction. In this case, the artist has chosen forms reflected in the water seen very close up. The result is a composition in the shape of a cross that combines contrasting bands and lines. The purity of the form in this subject adds a poetic element to the work.

Other Media

Wax crayons can produce surprising results, especially if lines are combined with areas of color. Since this medium can be diluted with a solvent, the artist was able to make a very diluted wash for the background color and for imparting a liquid feeling to the base. The wax crayon lines drawn over this surface define the forms of the movement of the water.

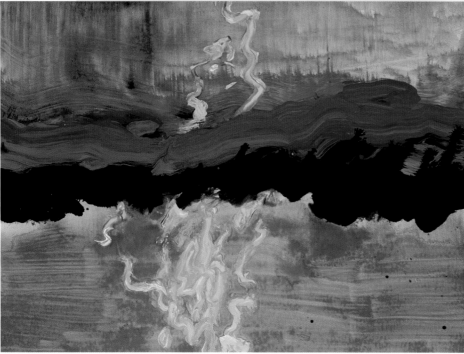

Other Views

Schiele (1890–1918) had a very different vision from that of Hockney. If Hockney painted refreshing and clean water, similar to something that could be seen in an advertisement today, Schiele treated his forms in an absolutely Expressionist manner, twisting the reflections and currents with a vibrant, broken line. The dense waters of the port of Trieste are certainly a reflection of Schiele's tormented spirit, very different from the optimism of Hockney.

Egon Schiele,
Port of Trieste, 1907.
Neue Galerie am Landesmuseum
Joanneum, Graz (Austria).

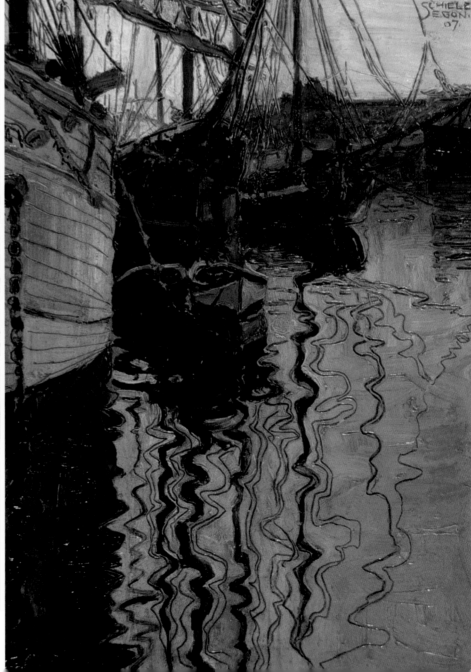

The human figure is the ideal painting genre for experimenting with the different ways form can be constructed. Three different creative approaches are offered in this chapter. In the first, the forms are built up using outlines to make very poetic synthetic and descriptive forms. In the second the form is constructed using chiaroscuro, creating corporeal and modeled forms. Finally, the creative potential of the figure in movement is revealed, generating Futurist forms similar to the Divisionist style.

Form in

the Human Figure

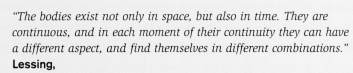

"The bodies exist not only in space, but also in time. They are continuous, and in each moment of their continuity they can have a different aspect, and find themselves in different combinations."
Lessing,
The Laocoön, 1716.

Synthetic, Descriptive, and Bordering Forms

The fascination with the nude is innate in human beings. People believed the body to be attractive, and they established a canon of beauty, of proportionality, and the first medium of communication with the world based on it. Although the body is a complex form, consisting of a series of additional forms, already in ancient cultures and even in the art of the 20th century there tends to be an interest in simplification. This simplification is normally reduced to line or color, developing the essential and elemental forms of silhouettes and outlines. Gustave Klimt (1862–1918), an Austrian artist of the Art Nouveau, founder of the Vienna Secession, focused a large part of his work on the feminine form, in paintings as well as drawing, creating works of extreme sensuality and refinement. In his figures, the volumes flow in perfect harmony, and they are brought to life with the movement of the line, not chiaroscuro. His line has an instinctive character. Klimt understood the line in the same way as Henry van de Velde during the early 20th century, who said it was *like a living being that, at every moment, is aware of the impulse that is hidden in it.*

Gustave Klimt,
Half Nude Woman Sleeping,
1906.

The Outline: Suggesting Anatomy Using the Poetry of the Line

The approach that we describe on the following pages is an exercise in looking at the human body poetically, searching out the forms that are created in each detail or part of it. Instead of working with the whole figure, we are going to focus on analyzing a profile and a half-length male torso, because of its suggestive volumes and the features of the face. The artist for this exercise, Gemma Guasch, has selected color pencils on paper as her medium. Pencils can be used to render a drawing with lines of different intensities. Line is going to be the conductor of the poetic view; therefore it is vitally important for the line to express the sensitivity of the artist and not become a simple graphic that records what is seen. The artist should take a free approach toward the model, each action a decision based on the previous ones, like a journey without a specific destination. Changing the direction or the scale of the contours, overlapping silhouettes, or focusing on small details and moving them from their logical places... This play will create new personal and suggestive forms.

"The world comes together in a line. With a line the world is divided. To draw is beautiful and terrible."
Eduardo Chillida,
Limits and Space, seventh aphorism, 1990.

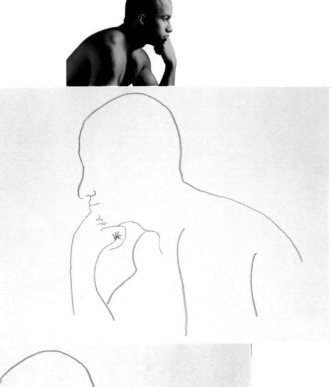

1 Going against logic and predictability, the main enemies of poetry, the artist begins by reversing the profile of the model. The right hemisphere of the brain is activated by changing the direction and the position of the model and encourages a more intuitive and sensitive response. The line that describes the outlines is drawn directly using a color pencil, without any previous sketching or blocking in.

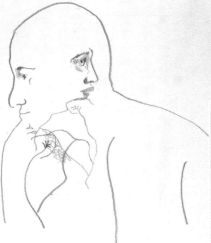

2 We draw a second profile facing the opposite direction with a pencil of a different color, generating a new form created by a connection, a form that expands the figure in a double vision, to the right and left. New interior forms begin to emerge, resulting from the juxtaposition of the outlines of the fists.

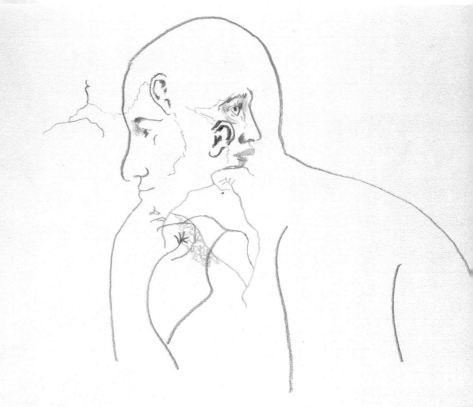

3 Some specific elements with sensual folds, like the ears and back of the neck, are drawn inside but out of place, without attaching them to the previously drawn faces. This way, the viewer will contemplate their particular beauty, like when we are fixed with wonder on a small part of the body, forgetting the rest.

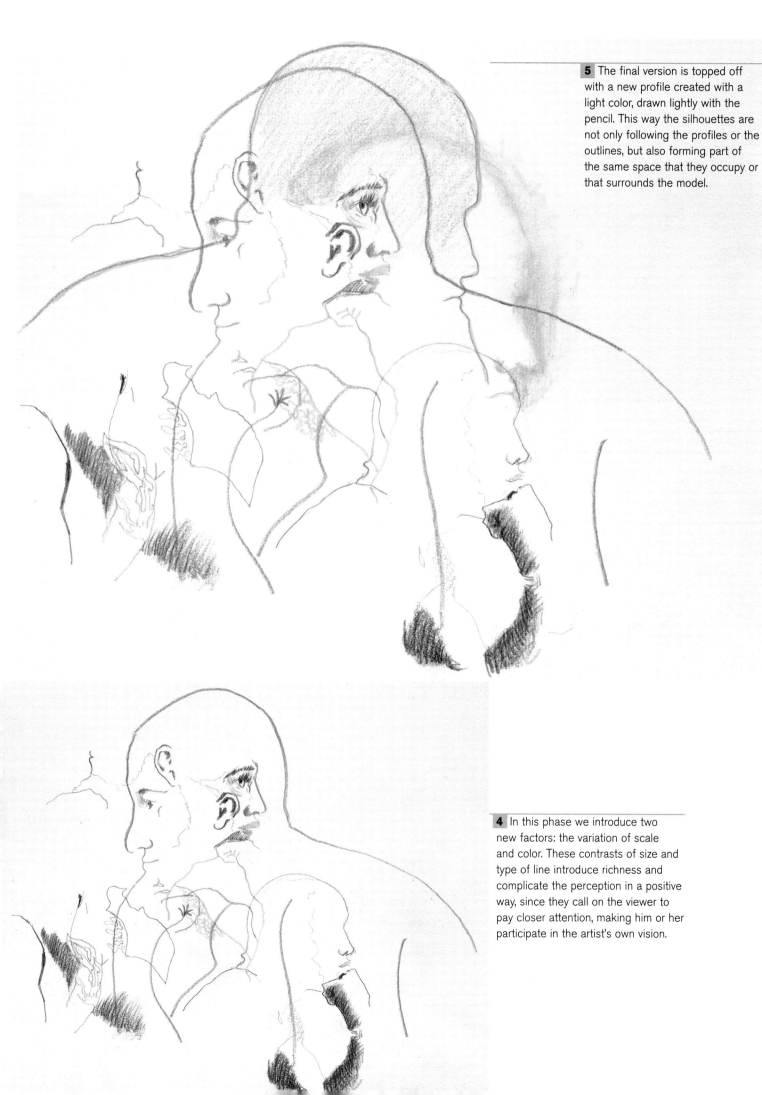

5 The final version is topped off with a new profile created with a light color, drawn lightly with the pencil. This way the silhouettes are not only following the profiles or the outlines, but also forming part of the same space that they occupy or that surrounds the model.

4 In this phase we introduce two new factors: the variation of scale and color. These contrasts of size and type of line introduce richness and complicate the perception in a positive way, since they call on the viewer to pay closer attention, making him or her participate in the artist's own vision.

Other Versions

The method that was used to create new forms with the line allows several combinations, and each one of them communicates a different message. Humans are changeable beings, and something that may seem to be of utmost importance one day can become of secondary importance the next. The gaze can settle on different places and discover new realities in what we thought had already been known. This is the concept behind the next exercise: an invitation to the discovery of, and fascination with, the nearby, while recognizing that the world is a complex universe that cannot be perceived from a single point of view.

A perfectionist image centers on the element on the model's skin: his tattoo. The line is serpentine and vibrant and approaches abstraction in some places.

Here the artist has played with different scales. The hand and its inside spaces also create new forms in its folds. The model's eyes stare into space and suggest a mysterious interior world that is extremely attractive.

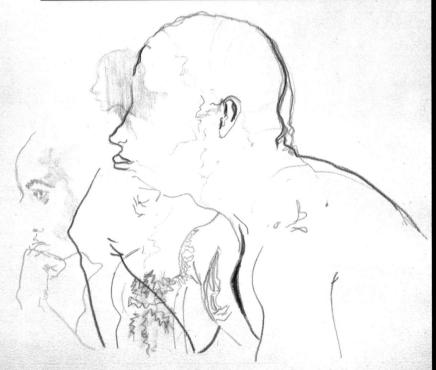

Using line and color the cranial structure of the model is reinforced, as well as the tensions that are established with the hand. Since there is no change of position, nor of scale, nor displacement, the message is direct: the musculature of the neck, back, and skull.

The perfection of the pencil line drawing of the figure combined with the deformation of the blue profile creates a double image that shows the same model with two different expressions, the multiple faces of a human being.

One form constructs the final image: a windmill. The model is positioned differently on the paper and the various points of view are combined. The different directions of the model's gaze reinforce the idea of intent observation.

This shows a simple yet direct solution, one model inside another. New spaces are created by overlapping lines. The incomplete forms are a creative approach that demands a perceptive response from the viewer, who will certainly be captivated by it.

New Approaches

Other Models

The best models for creative work of this kind are the most familiar ones, and what is more familiar than your own body or that of a friend or family member? A hand or a foot or a face reflected in a mirror are sufficiently arresting subjects for creating beautiful work. A hand is a complex form made of a flat mass with some relief: the palm, and five extremities that are each articulated at three flexing points: the fingers. There is also the joint where the wrist attaches to the hand. In other words, the hand contains many forms in one.

Other Media

The clean lines of this piece can be drawn with other media: pen and ink, chalk, wax crayon, markers, etc. Here we show two works by the same artist, created with color chalk on large supports of fine wool fabric. This time the models are family members. The forms that are born of this project have a vitality that enriches the expression of the work.

Other Views

Until now we have seen form studies based on interior and exterior outlines, the creation of transparent silhouettes. Another way of approaching this type of work is using color, perceiving the mass of the body as a whole without internal spaces, like shadow puppets or paper dolls. Isidre Nonell (1873–1911), when looking at his models, synthesized the physicality of the person through the use of light chiaroscuro or dense masses of great beauty and presence.

Isidre Nonell,
Loneliness, 1902.
Private Collection.

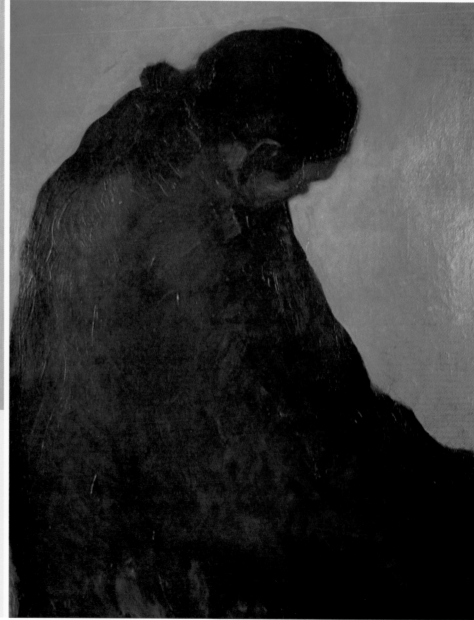

Corporeal, Modeled, and Contrasted Forms

Creative Approach 12

If we study the forms of the human figure from a sculptural point of view we should agree that the most appropriate way of expressing them is with volume. During the Baroque period the technique of chiaroscuro was developed and perfected as the ideal method for representing the masses of the body. Rembrandt (1606–1669) was one of the greatest painters of the Baroque. In his paintings warm light bathes the figures, modeling them in a dense and intimate atmosphere. The representation of a woman's bath shown on this page is a perfect synthesis of his very personal style. The delicate and thick brushstrokes that give body to the figure model it by using a chiaroscuro with great contrast. This chiaroscuro technique emphasizes dark and undefined backgrounds and the use of a single focused and hard light source.

Rembrandt,
Woman Bathing, 1655.
National Gallery, London
(United Kingdom).

The Nude: Revealing the Form with Chiaroscuro

In the following exercise we are going to experiment with chiaroscuro. We will begin with a model in front of a black background, illuminated from the side with a harsh light. The artist for this project, Josep Asunción, has chosen to use scraping, a very unconventional technique, along with drawing ink as the medium. Starting with black he will proceed to bring out the volumes of the figure by scraping the painted surface of the paper until the light of its original white color is restored. The chiaroscuro technique does not require that the complete form be revealed; rather it invites you to leave some areas in shadow, where, as we saw on page 11, they are completed in the mind following the perceptive law of closure.

"In painting the human figure, it is not necessary to make it; it is necessary to make its atmosphere."
Futurist Painting:
Technical Manifesto, 1910.

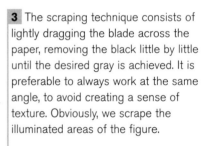

1 We prepare the background by painting black india ink on a nonporous paper, preferably clay coated with a satin or glossy finish. At least two coats should be applied, alternating the direction of the brushstrokes. It is a good idea to attach the paper to a board with adhesive tape to prevent any buckling.

3 The scraping technique consists of lightly dragging the blade across the paper, removing the black little by little until the desired gray is achieved. It is preferable to always work at the same angle, to avoid creating a sense of texture. Obviously, we scrape the illuminated areas of the figure.

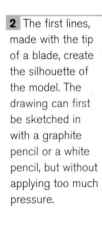

2 The first lines, made with the tip of a blade, create the silhouette of the model. The drawing can first be sketched in with a graphite pencil or a white pencil, but without applying too much pressure.

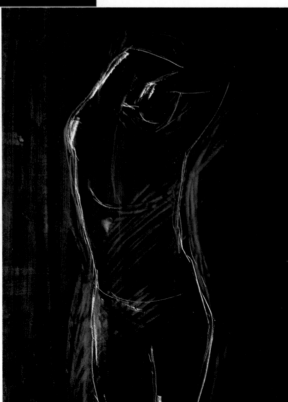

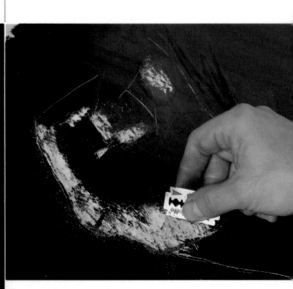

5 The final task consists of adjusting the relief of the body by lightly scraping and hatching the background with more gestural lines. The textured background will emphasize the softness of the feminine figure. Next, we add color inks so that the result will be less dramatic.

6 This is the finished work, in full color. A warm range of yellows and purples has been used for the light and shadows. The effect is more lively and painterly than black and white.

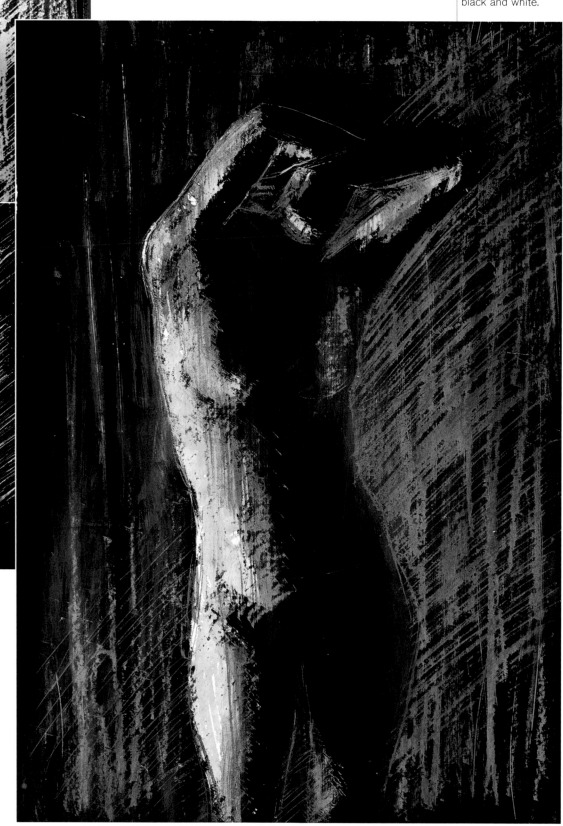

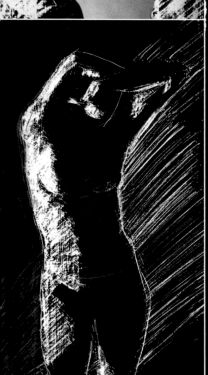

4 We create a light background behind the figure to help it stand out. Alternating positive and negative will balance the composition in terms of the chiaroscuro.

Other Versions

The scraping technique allows experimentation with chiaroscuro forms, which can be darker or lighter according to the direction and pressure of the scraping. This time the artist has done four very different exercises in the same style. In all of them the atmosphere defines the form through the effect of the light.

This composition in black, white, and orange is the most contrasting of the gallery. Leaving the light areas of the figure pure white causes it to advance toward the viewer, and the space it occupies stays far behind. The direction of the scraping is a combination of vertical and horizontal.

This is the darkest painting and the least contrasting. All the visual elements are articulated with quick and vibrant lines that tangle themselves so much they create hatching. The effect is electrifying, as if the body is dematerializing.

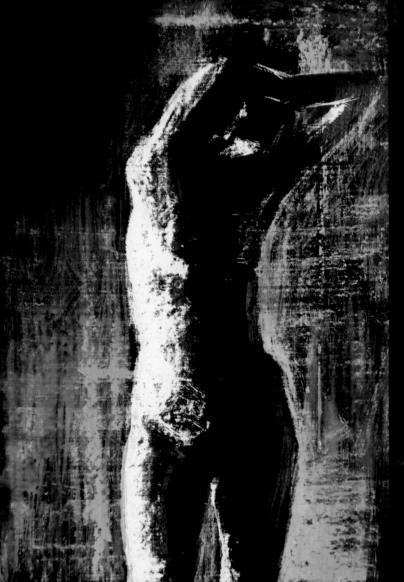

In this closer view of the model, the painter plays with a variety of lines. There is angled and linear scraping in the background, there are rough and flat lines on the figure, and the color inks brushed over them add different values to the modeled elements.

The scraping in this picture is always in the same direction. This uniformity creates a unique atmosphere. To correct a mistake in the illuminated area of the model, the artist has painted over it with a small amount of diluted white gouache, since there is no opaque white artist's ink.

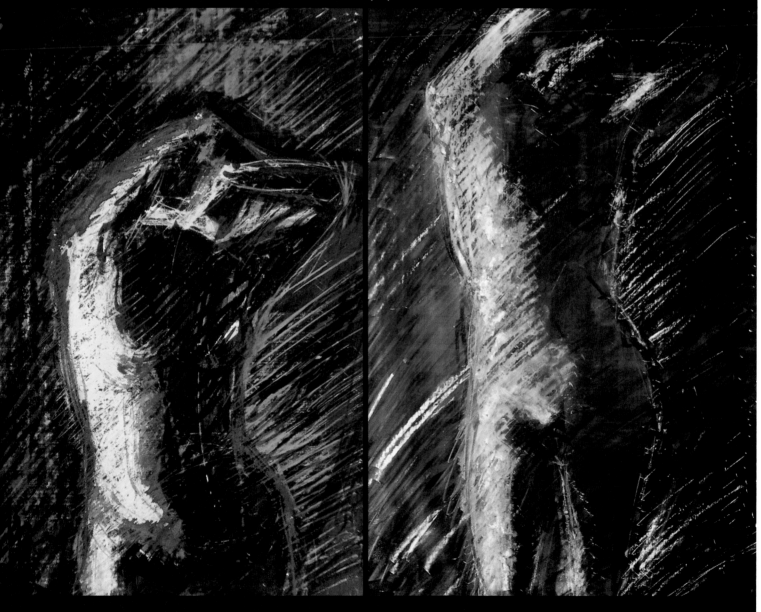

New Approaches

Other Models

Continuing with the same type of dark image, the artist wished to represent the model in a more dynamic and suggestive pose, in which some areas of the figure are hidden in the darkness of the background. The finished painting is very attractive because of the looseness of the scraping and the rich play of contrasts between light and shadow.

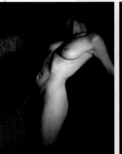

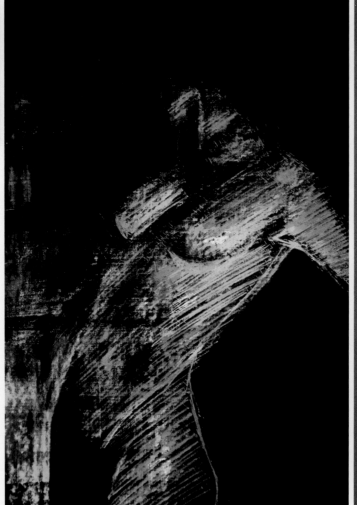

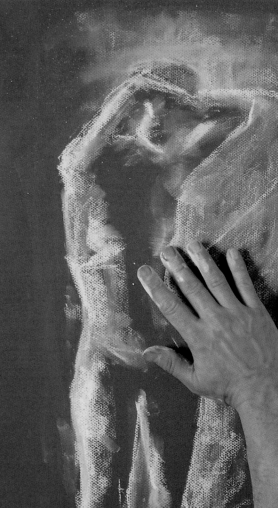

Other Media

Changing the medium, the artist has painted the model in pastels on Canson color paper. Here we present a sequence of steps to show how these atmospheric effects are achieved through rubbing and chiaroscuro applied with loose lines.

Other Views

Next we will see two completely different approaches to modeling the human form. The first case is that of Fernando Botero (born in 1932), who models the figure using large and rounded, almost spherical forms. The chiaroscuro is very light, with hardly any contrast, as if the body mass stretched the skin and eliminated any relief.

The second is by Montserrat Gudiol (born in 1933), who resolves the chiaroscuro with great sobriety of color and form. Gudiol's figures remind us of chiaroscuro paintings by Rembrandt and Caravaggio, where the figure emerges from the darkness to show itself only partially.

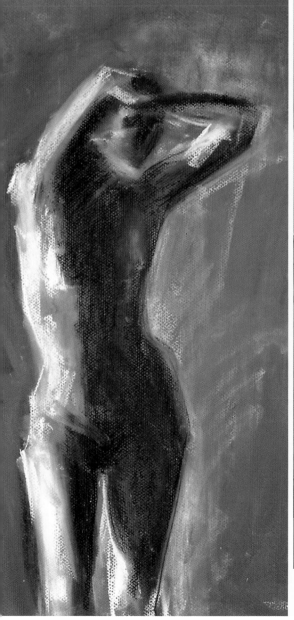

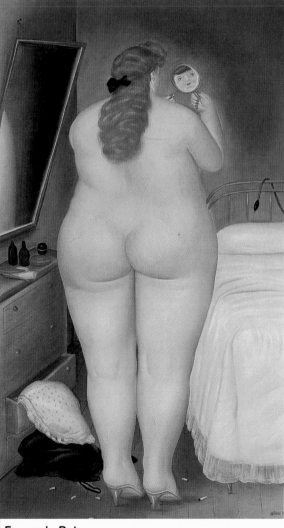

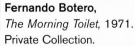

Fernando Botero,
The Morning Toilet, 1971.
Private Collection.

Montserrat Gudiol,
Seated Woman, 1981.
Private Collection.

Divided, Inserted, and Futurist Forms

Creative Approach 13

As Lessing said in Laocoön (1716), *"bodies exist not only in space, but also in time. They are continuous, and in each moment of their continuity they can have a different aspect, and find themselves in different combinations."* This principle of the variability of the form was taken up again in an experimental manner by the avant garde during the 20th century, especially by the Cubists, Dadaists, and Futurists. One of the most relevant artists of this period, and also certainly of the 20th century, was Marcel Duchamp (1887–1968). This artist, who had a strong personality, quickly became independent from the official movements of his time and created a very personal body of work that was extremely interesting conceptually and artistically. One of his best-known works was the *Nude Descending a Staircase,* which was based on various sources, like the chronophotographs of Muybridge and Marey. His success is due, in part, to the scandal caused by its exhibition at the New York Armory Show (1913).

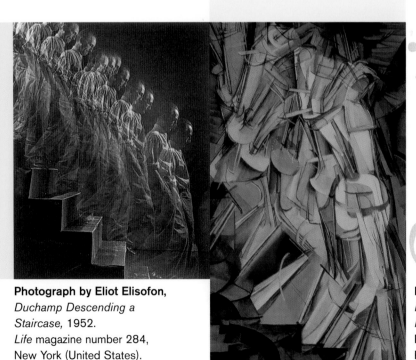

Photograph by Eliot Elisofon,
Duchamp Descending a Staircase, 1952.
Life magazine number 284,
New York (United States).

Marcel Duchamp,
Nude Descending a Staircase, Number 2, 1912.
Philadelphia Museum of Art,
Philadelphia, Pennsylvania (United States).

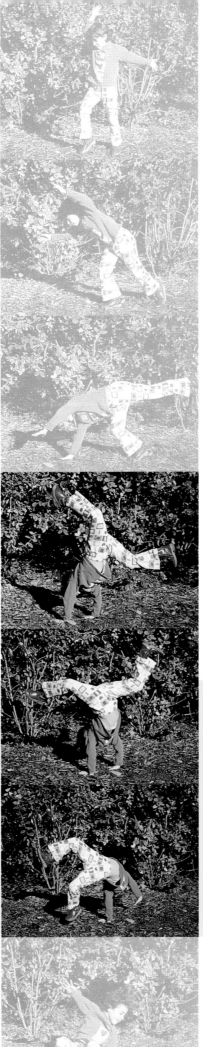

The Figure in Movement: Interpreting the Forms That Generate Dynamism

In this approach we are going to work with the form of movement. When a figure moves, its forms move, and they look different at each moment of the displacement. These variations of form can clearly be seen in sequenced photographs. The painting technique that develops these moving forms is called Divisionism, and we are going to apply it here. We will begin with a photographic sequence showing a girl doing a cartwheel. From this sequence, the artist, David Sanmiguel, focused on three moments, and based on them he has developed a beautiful fan shape using acrylic paints. The paint is applied with both small and wide brushes. The masses and spaces join and overlap to create new forms, the forms of movement.

"Everything moves, everything runs, everything happens quickly. A figure is never still before us, but appears and disappears incessantly. Through the persistence of the image in the retina, things in motion multiply, deform, following each other like vibrations in the space they move through."
Futurist Painting: Technical Manifesto,1910.

3 The space in which the figure is placed becomes denser and takes on form. The paint is spread with a palette knife and brush, using quick motions to add dynamism to the form.

1 The first step was to draw the overall form of the cartwheel in pencil. Notice how some parts of this form stay still, like the hands braced against the ground, while the legs fan out to create Divisionist forms.

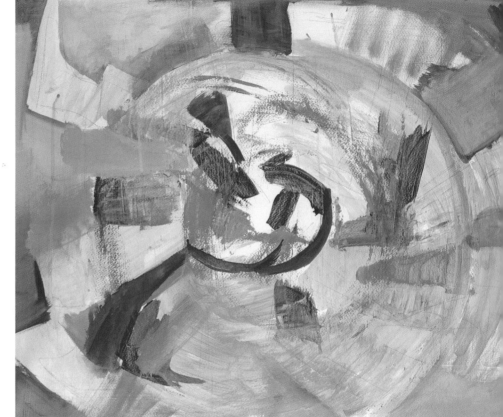

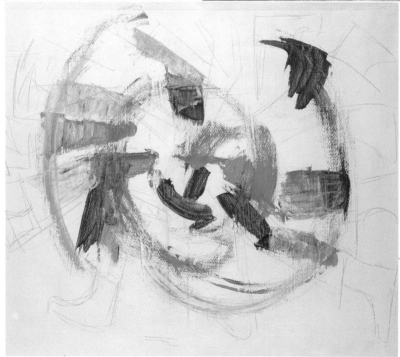

2 A spiral indicates the structure of the forms. This geometric shape is applied at the beginning to add dynamic character to the work, and it will reappear at the end as the culmination. In this step fairly diluted paint is applied, and it will become denser as the picture progresses.

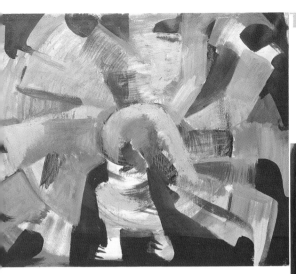

4 We separate the body from the background with a flat form so it will not become confused and lose all reference to the model. Then we define the still part of the girl's figure, a more stable form, with marked outlines.

5 We recover the initial forms by contrasting profiles, colors, and chiaroscuro. This way, the image of a form unfolding definitely becomes apparent, and this brings back the sequence of photographs.

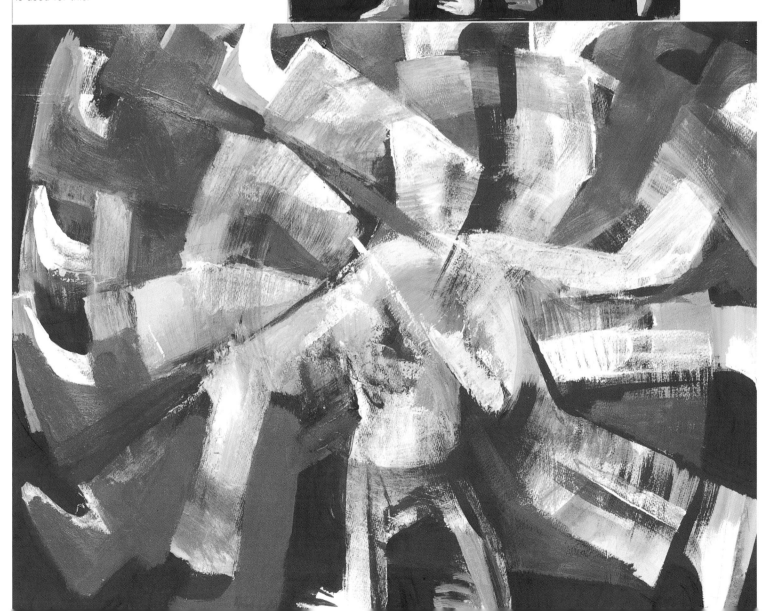

6 Finally, we smear the scene with a spiral stroke to reestablish a sense of speed. A wide palette knife with a small amount of paint is used for this.

Gallery

Other Versions

A visual reading of the girl's movement allows us to focus on different aspects of form: the overall form that is described, the external outlines of a new form, the contrast between the static body and the dynamic body, the forms of the intermediate spaces, etc. David Sanmiguel used acrylic paint to work with all these aspects in the different versions of the same model.

A version with a limited number of elements creates a clean and clear visual effect. The partial forms are not blurred at all. From this point of view it is not a Divisionist form, only juxtaposition. The girl's navel graphically marks the center of rotation.

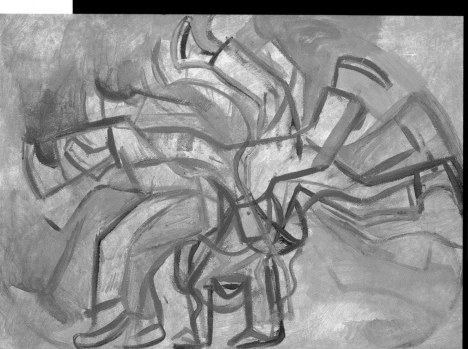

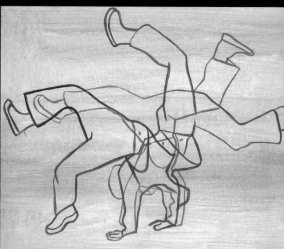

The structural shape of this work is defined by an ellipse, which is neither explicit nor outlined, but the result of the combination of the partial forms of the feet. The line still describes only the outlines.

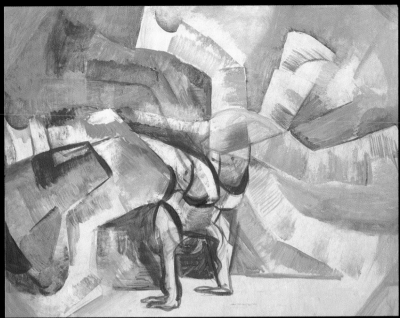

To emphasize the fact that one part of the form stays still and another part continues in motion, half of the girl's body, the part that is anchored to the ground, is very well defined. Indicating the ground plane adds strength to this contrast; also, the part in motion has been greatly blurred, as if it were moving fast.

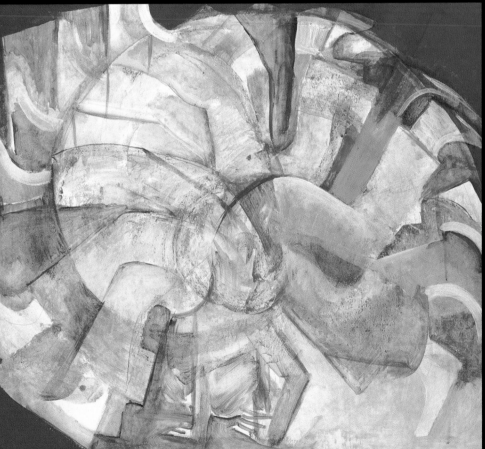

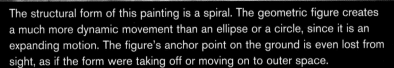

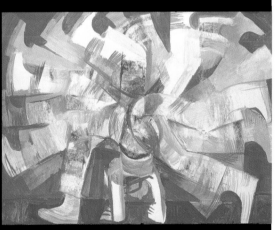

This is the version containing the most of all the elements: static-dynamic contrast, spiral structure, a balanced combination of line and color, and outlines and wiped paint.

The structural form of this painting is a spiral. The geometric figure creates a much more dynamic movement than an ellipse or a circle, since it is an expanding motion. The figure's anchor point on the ground is even lost from sight, as if the form were taking off or moving on to outer space.

New Approaches

Other Models

A simple movement of hands or feet is sufficient for creating Divisionist images. David Sanmiguel has developed the theme of a hand game that describes a more geometric, polygonal form along the same lines as his previous work with the cartwheel. Here the work is more complex but very rich in its variety.

Other Media

Divisionist forms can be fully expressed in any medium since they are based on linear structures. If the intermediate forms of the sequence are developed, this can be done with more or less density, even using hatching if the work is done in a graphic style. Here are two examples of the same image done in pen and india ink. As can be seen, the line and hatching techniques are the structural axis of the forms.

Other Views

Giacomo Balla (1871–1958) was one of the major proponents of Futurist painting. The Divisionist work shown here was surely inspired by a photograph taken of him that same year by the film and theater director Antón Giulio Bragaglia (1890–1960), as well as the photographs by Edward Muybridge and Étienne-Jules Marey at the end of the 19th century. The hand defines a well-defined arc-shaped movement on the violin, and it seems to emit sound.

The other view that we show is very different, since it is not Futurist, but Impressionist. In this work by Henri-Marie Toulouse-Lautrec (1864–1901) the movement is depicted with a sinuous form that is reminiscent of the fluttering of a veil in the air. These aerodynamic forms always suggest movement.

Giacomo Balla,
Rhythm of the Violinist, 1912.
Estorick Foundation,
London (United Kingdom).

Toulouse-Lautrec,
*Loïe Fuller at the Folies
Bergère,* 1892–1893.
Albi (France).

Abstract forms are those that are not related by the viewer to known objects of the visual world. There are two general types of abstract forms: those of an organic character, which are more rounded and flowing, and the geometric, which are flatter, straighter, and more graphic. This chapter includes the last two creative approaches. They are two abstract forms, one of each type, and both originating from very different visual realities, a walnut and an urban landscape.

Form

in

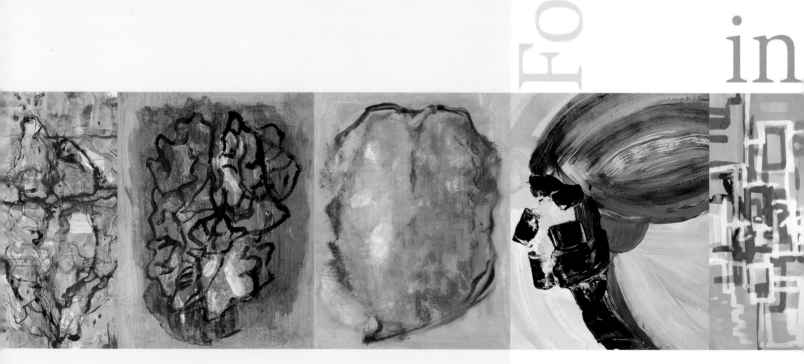

Abstraction

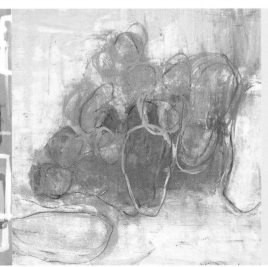

"Abstract painting is wider, freer, and richer in meaning than that of 'objects.' Pure sound comes to the foreground. The soul enters into a vibration without object, which is more complex, 'suprasensory.'"
Wassily Kandinsky,
Articles from 1923 to 1943.

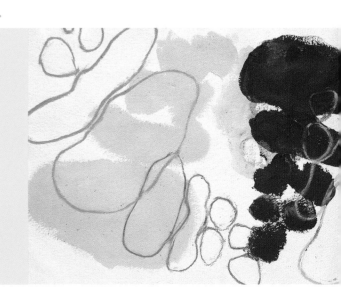

Twisting, Gestural, and Organic Abstract Forms

The first abstract painting in history is attributed to Wassily Kandinsky (1866–1944), a watercolor painted in 1909. The work of this painter, who had an investigative spirit, is characterized by its rigor and reflection. Besides being a painter, he was a great pedagogue with enormously valuable theories. He knew how to transmit his discoveries, not only in his classes, but in his writings. The development of form and color in his abstract compositions began with a particular concept of the visual phenomenon relating to the world of sound. Forms and colors distributed in pictorial space acted, according to Kandinsky, like the instruments of an orchestra in a musical piece. Each form and color corresponded to a vibration, with its own properties. For Kandinsky the abstract is not disconnected from nature, it forms part of it, so although he apparently abandoned what he called the "skin of nature," in reality he expressed its laws and connected with its inner soul.

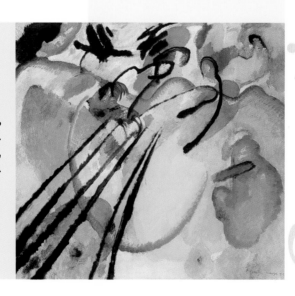

Wassily Kandinsky,
Improvisation XXVI, 1912.
Städtlische Galerie,
Munich (Germany).

The Universe in a Nutshell: Abstraction Based on a Specific Form

An image is considered abstract when the viewer cannot identify it with his or her visual culture and cannot relate it to an object. But this limitation does not mean that the origin of an abstract image is not absolutely natural and real. In fact, many natural forms and spaces in nature and its surroundings are very abstract if they are taken out of context or observed from strange points of view, such as through a microscope or from an unusual angle. Although not all abstract painting begins with nature, in this approach a process of abstraction will be developed based on a specific form: the inside of a walnut. The method that the artist, Gemma Guasch, is going to use consists of changing the scale of the image so that the detail of a tiny object, in this case a walnut, covers the surface of a large painting. Working with abstraction in this way implies entering into a process of continuous decision making. Each form opens a door to the next, like the succession of twists and turns in the walnut, alternating colors and lines of different nature until a final image that is far from the figurative representation of the initial motif is created. Wet techniques such as glazing, dripping, and wet lines, primarily of watercolor and very diluted acrylic, have been used for this model.

"My God! I could be imprisoned in a walnut shell and I would consider myself king of an infinite space."
William Shakespeare,
Hamlet, Act 2, Scene 2.

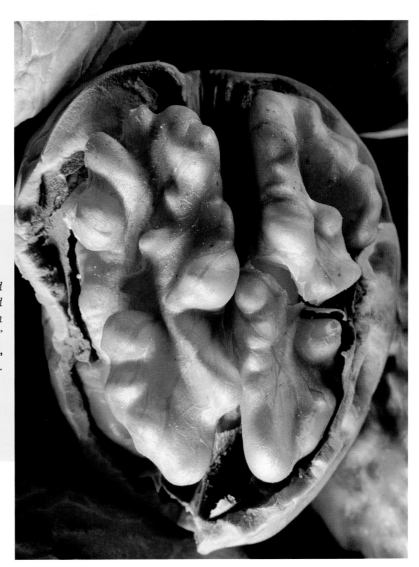

Form in Abstraction

"A painting is not conceived and determined beforehand. While one is working on it, it is modified as quickly as the mind changes. And once it is finished, it continues being modified, according to the mood of whoever contemplates it."

Pablo Picasso,
Words and Confessions,
1954.

1 The initial layout that simplifies the form from the beginning is interpretive and expresses the artist's free viewpoint, which settles on the aspects of the model that most catch her attention.

2 The first applications of color divide the central form into two areas. One is more in the background, and the other stands out and is more luminous.

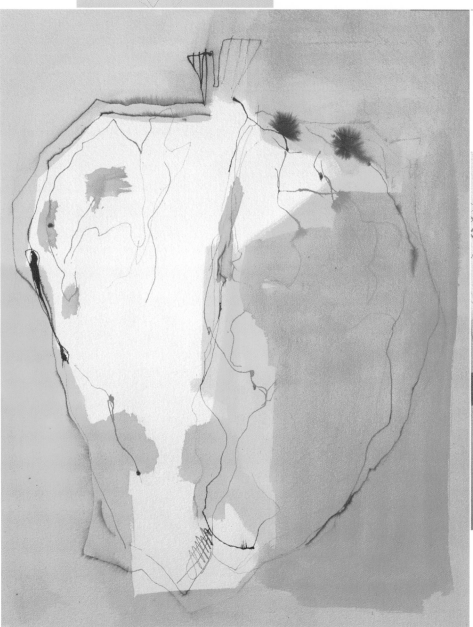

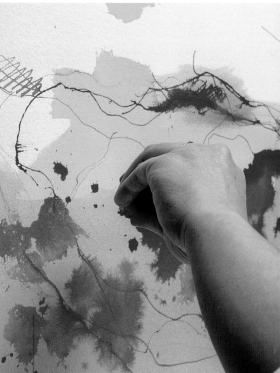

3 To add interest to the color area, we drip paint by squeezing a wet sponge from above the paper onto the paint while it is still wet.

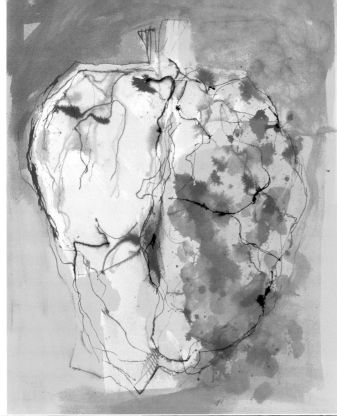

5 Twisting lines are drawn with a reed pen to evoke the character of the folds of the inside of the nut. The white is partially colored with clear water to soften the contrast of light, and the upper part of the background is darkened even more.

6 Observing the walnut from another angle, more twisting lines are added, and new wavy lines are made using blue applied with a wide brush and also with white wax crayon, breaking down the boundaries between the form and the background.

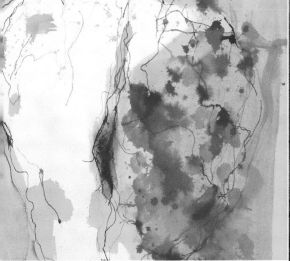

4 We add a darker tone of orange to break up the division between the left and right sides of the painting, and that balances the texture made by dripping.

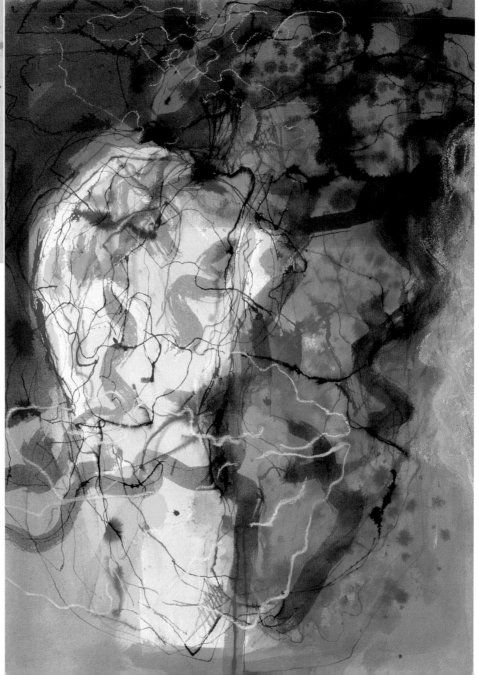

Other Versions

Gallery

An abstract painting is not necessarily an improvised painting. Many abstract painters work with very defined projects based on form studies, without leaving much room for luck or accidents. But the artist for this creative approach focuses her attention on the process and not on the project. Her working style is very free and she pays close attention to each effect, since this is an invitation to experiment with another way of approaching form. Each effect contains a discovery. As Joan Miró said in an interview in 1948, "even the marks made by my brush when I clean it can inspire the beginning of an image."

The lights and folds of the walnut have been applied with a brush over a background scrubbed with acrylic paint.

This effect was created with very diluted acrylics on a heavily textured base, allowing them to drip and moving the streaks around in a controlled manner. The movement of the liquid paint imparts dynamism to the form.

Dripping watercolor over a white acrylic form placed horizontally on a yellow watercolor background creates loose, twisted, and serpentine forms. The results are fresh and spontaneous because there are few, although critical, steps involved.

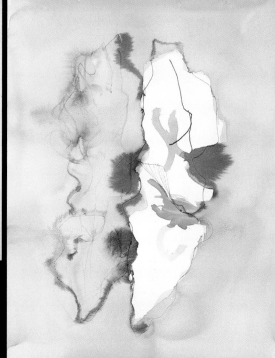

In this work the artist has attempted to represent the folds of the walnut, creating more angular and tense forms.

A more airy version of the same form is painted with washes and a few lines made with a reed pen. The watercolor, applied over a damp surface, spreads to create a soft and modulated feeling.

Other Models

The exercises based on a walnut did not stray far from the character of the fruit. The theme of the folding forms in the interior volumes guided the development of the work, and those forms are present in some way in all the versions created. But in nature there are many other abstract features, such as texture, airiness, softness, hardness, angularity, etc., depending on the model being used. Let's look at other approaches that are very different in nature.

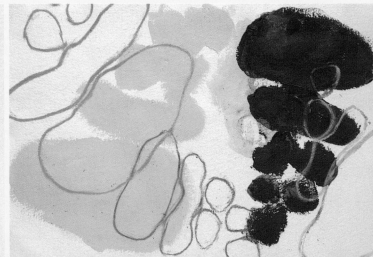

The worn shapes of river rocks suggest abstract compositions with rounded structures, ellipses, circles, and ovals, enveloping lines and interesting spaces. The rounded forms, reminiscent of the organic world, convey warmth and are very pleasing to look at. These two versions of the same subject are examples of the delicate poetry created with lines and colors.

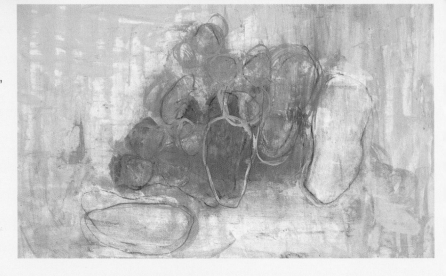

Other Media

In these two versions the artist has chosen to use a medium that is not water based, oils, to create a stronger sense of physicality. The results are much thicker since they are an oil-base medium, and they can be blended better than acrylics and watercolor because of their slow drying times. In both cases, the forms have a dense and physical appearance, through either the earth tone impasto applied to the canvas with a spatula, or the wiping and blending of the other version.

Other Views

Abstract art, which constructs the image from the gesture born of the act of painting, often depicts twisting organic forms. These forms evoke the idea of connection or of a structural web, and they have a warm character. Some artists have developed a more abstract body of work than others, through the narrative references of the images they produce. For example, Joan Miró (1893–1983) used organic forms in his abstract compositions, although he related the gestures to signs, sometimes symbolic, as newly created forms of archetypal or dreamlike figures. On the other hand, Jonathan Lasker (born 1948) makes purer abstractions, avoiding symbolic or narrative connotations, giving forms a life of their own and creating dialogues between them within their own space.

Joan Miró, page from the artist's book: *Unfailing,* 1958. Private Collection.

Jonathan Lasker,
To Believe in Food, 1991.
Private Collection.

Geometric, Graphic, and Planimetric Abstract Forms

Geometric forms in nature are quite rare, although they do exist in the structures and growth systems of living creatures. The tendency to make something geometric is a very typical human characteristic, probably because we have these structures inside ourselves and because they bring order to the chaotic and amorphous. Just as in figurative painting, abstract painting is constructed with graphic icons. Because geometric forms lack narration and have an abstract nature, they are a very popular resource for abstract artists. Sean Scully (born in 1945) bases his work on square and rectangular geometric planes. He reinforces the shapes using layers of color (normally neutral) to strengthen the role of the surface and the flat forms. Scully reformulates Mondrian's abstraction by adding more material aspects; therefore he prefers to work in oils. This painter has always associated these types of forms with the urban world, which for him constitutes the purest expression of the human genre elevated to the extreme.

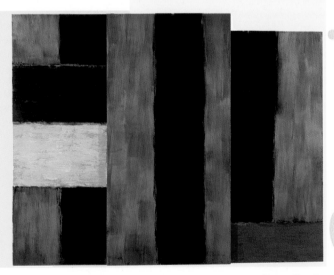

Sean Scully,
Flesh, 1985.
Private Collection.

The City: Generating Abstract Forms from Geometric Structures

To conclude this series of approaches we undertook the challenge of creating an abstract painting with a geometric structural form. Wanting a subject to inspire the forms, the artist Gemma Guasch has chosen an urban landscape. Acrylic painting techniques are used, and the chromatic range for this project is limited to three colors—white, black, and red—so the forms will not be overpowered. The visual interest in this work is in the combination of planes and lines that create interlacing forms in a personal space. As we will see, the painting takes on a life of its own and becomes a separate entity from the initial model. This is the main objective of the approach.

"Since human nature always suffers the consequences of the most extreme urban situations, I try to subvert and humanize the inexorable repetition of these forms through reinterpretation and subjective intervention."
Sean Scully,
Conversation with Demetrio Paparoni, 1992.

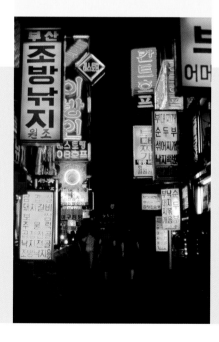

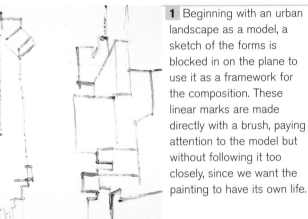

1 Beginning with an urban landscape as a model, a sketch of the forms is blocked in on the plane to use it as a framework for the composition. These linear marks are made directly with a brush, paying attention to the model but without following it too closely, since we want the painting to have its own life.

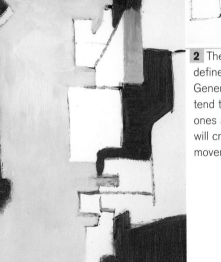

2 The first areas of color define the gray values. Generally, the dark tones tend to recede and the light ones advance. This variety will create a very rich visual movement in space.

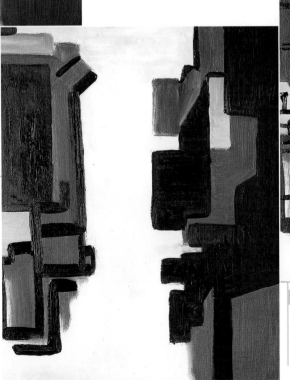

3 Now all the forms are filled with color. They are dense, ordered planes that conform to the original framework. A few lines based on this framework are added, but they are creating new, more independent forms.

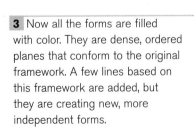

4 We create a second structure of lines, with a finer brush, that will visually echo the first one. It does not alter the composition at all, but repeats the same rhythm and adds transparency to the forms.

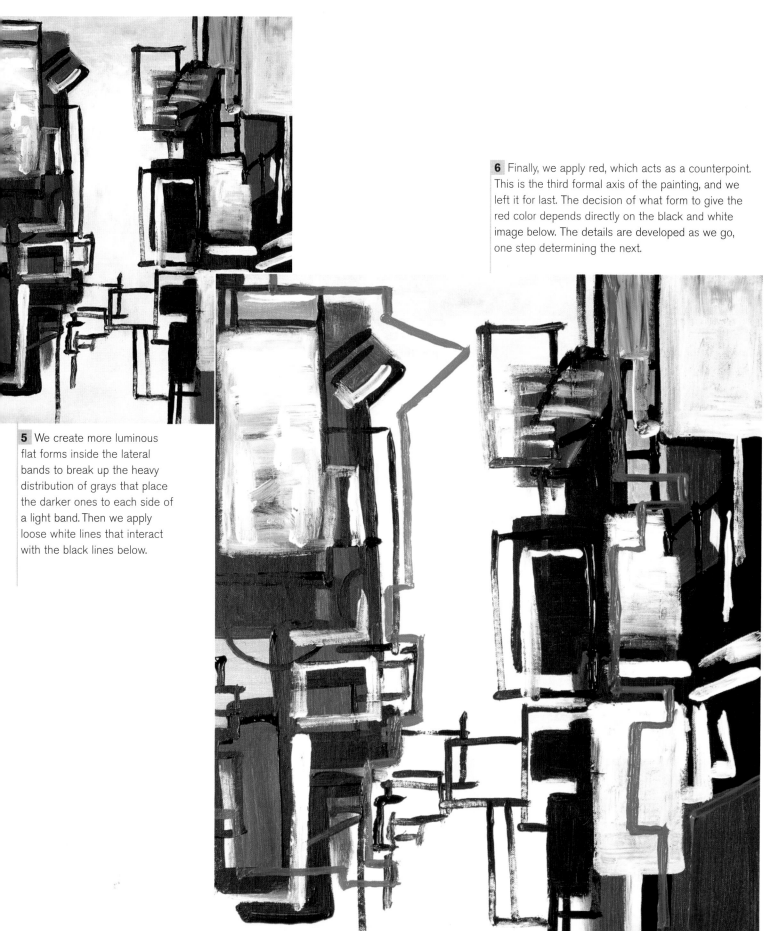

6 Finally, we apply red, which acts as a counterpoint. This is the third formal axis of the painting, and we left it for last. The decision of what form to give the red color depends directly on the black and white image below. The details are developed as we go, one step determining the next.

5 We create more luminous flat forms inside the lateral bands to break up the heavy distribution of grays that place the darker ones to each side of a light band. Then we apply loose white lines that interact with the black lines below.

Gallery

Other Versions

The original image is just a source of inspiration to encourage the creation of specific kinds of forms, in this case, a very angular composition in vertical bands with flat and rectangular forms. This is the basic idea, which can be used as the starting point for several paintings, like those in this gallery.

Having just a few elements in a painting, like this one (a combination of silhouettes and outlines, negative and positive space), creates a sense of purity of form. This is the most direct and radical version, as well as the most contrasting.

The geometric forms of this composition are stacked one on the other, just like the cut stones in a wall, sometimes letting in light, like openings or windows in the dark.

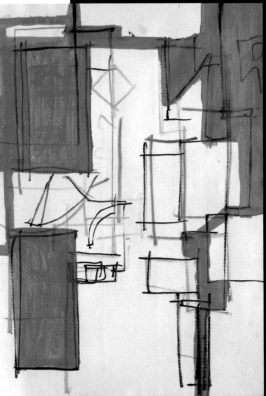

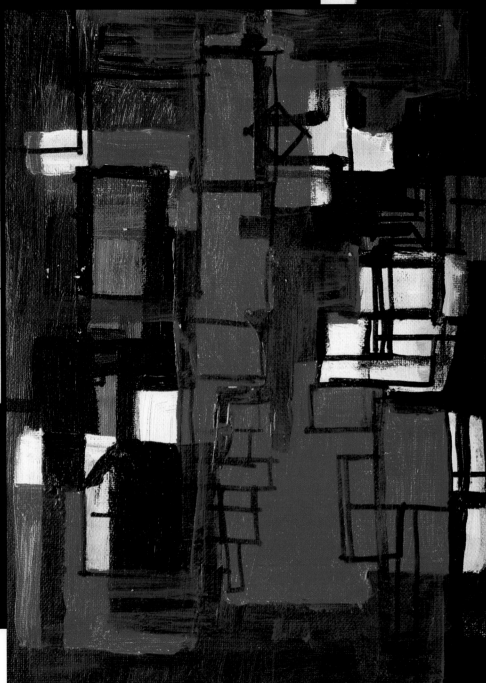

The large surfaces of the flat and luminous forms interact here with a very transparent linear structure. The abstract architectural forms do not rise from the ground, but are seen from above, like the floor plan of a building.

In this painting we perceive a large complex form, composed of many internal forms like compartments in a single space. The red wash and the loose brush lines inside give the large form a painterly feeling and a more atmospheric quality.

In this painting two large gray forms with a lot of texture from the variety of techniques used (brush lines, scraping, and glazing) face each other on a black and empty background.

This is another direct and clean version. It is worth pointing out the combination of the line hatching in the foreground, drawn with a marker, and the flat areas behind, in red acrylic.

New Approaches

Other Models

For a change from the square shape of the previous compositions, Gemma Guasch has chosen an alternative model based on diagonal and diamond shapes. The two versions shown here demonstrate the possibilities offered by geometric forms if the work is done quickly and freely, forgetting the model and focusing on what is required by the painting as we go along.

Other Media

Artist's ink is a wet medium that is very different from acrylic paint. The ability to oxidize the ink with bleach allows the artist to draw forms that erase the color below and create a surprising luminous effect, as seen in these two versions.

Other Views

Peter Halley (born 1953) is another contemporary painter, like Sean Scully, who works abstractly and is known throughout the world. He is attributed with the invention, in the 1980s, of what was called the Neo-Geo Style, or Neo-Geometric Conceptualism. The main characteristics of this painter's work are a very Minimalist look, because of its coolness and the industrial paint he uses, and the influence of the works of Mondrian and especially Albers. He is also a teacher and a prestigious art critic.

Peter Halley,
Full Contact, 1994.
Private Collection.

Wet Media

These media are composed of a mixture of pigment, agglutinant, and a solvent. They can be classified in two groups according to the solvent they contain: oil base and water base.

The following pages include the basic concepts related to the media, the supports, the applicators, and the techniques used in the creative approaches outlined in this book.

OIL-BASE MEDIA

The solvent used in oil-base media is an essence, which can be of either vegetable or mineral origin. The vegetable essences are essence of turpentine, which is more refined, and paint thinner, which is less. The mineral essence derived from petroleum is mineral spirits, a substitute for paint thinner.

Oils

Oils have been one of the most valued media in the history of painting. They have an oily and pasty consistency, made of tints or pigments mixed with an agglutinant: walnut, poppy, or linseed oil. It is preferably diluted with a vegetable essence, turpentine, or paint thinner. It is available in tubes of different sizes from 1¼ oz. to 8 oz. (5 to 200 ml) or in 1-gallon (4-liter) cans. The prices can vary a lot according to the initial cost of the pigment. The earth tones are the least expensive, whereas the cadmiums can cost four times as much. Today, less expensive colors have been created, substituting synthetic pigments for natural ones.

Oil paints have a very slow drying process; this permits the forms to be blended and retouched, and allows more time for working on the painting. The colors are bright and intense, and lose little brilliance in the drying process.

Canvas, wood, or hard cardboard supports are recommended for use with this medium.

The most appropriate brushes are those with real or synthetic bristles; the spatula is recommended for use with impasto.

Wax Crayons

Crayons are made by mixing pure pigment with animal oils and waxes. Then they are formed into sticks of different colors that will make a thick and creamy mark. Their tones are intense and bright, and can be mixed on the support by rubbing with cotton, a paper towel, an eraser, or the fingers, which will create a smooth, bright, and oily texture. The colors can also be diluted with a brush or a paper towel impregnated with turpentine or thinner, to create a transparent effect. It is an ideal medium for the sgraffito technique, which consists of scratching areas of wax applied over a previously colored support with a sharp instrument (a blade or a craft knife) to create very special forms and textures.

It is also a very useful medium for making reserves: first, a drawing or an area of color is made on paper with wax colors, then ink or

Wax Crayons

watercolor is painted over them. Since the wax repels any water-base medium, the area covered with wax remains unpainted. Wax crayons are sold in boxes of assorted colors or individually at very reasonable prices.

Paper and cardboard are ideal supports. It is recommended to fix the artwork by spraying it with lacquer or a fixative when it is finished.

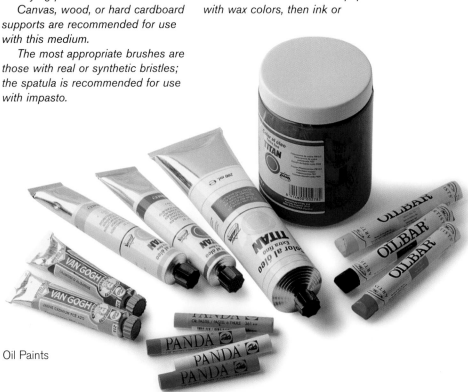

Oil Paints

WATER-BASE MEDIA

Regular tap water, or distilled water, which prevents granulation, is used as a solvent for this type of medium.

Drawing Inks

Acrylics

Acrylics are made with pigments bound with synthetic resins. They are known for their fast drying time and the fact that they do not turn yellow with the passage of time. They are very versatile, offering the advantages of watercolors when diluted with a large amount of water, or the thickness of oils if used without water. Acrylics have a soft and creamy consistency, very similar to oils, making them ideal for painting impastos. They can be diluted with water or an acrylic medium. The mediums, glossy, matte, and gel, can be used to increase the glossiness and depth of the colors. We can delay the drying time by adding glycerin or a retardant medium. Acrylic paint has a uniform, matte finish, but we can restore the glossiness by applying a thin, transparent coat of acrylic varnish. This should be applied over the paint when it is completely dry, so it is a good idea to wait for a day. The varnish can be matte or gloss, or the two can be mixed to create a semigloss finish.

Acrylics are available in tubes of different sizes or in cans at very reasonable prices. It is a very durable medium that can be painted with any type of applicator on almost any support.

Acrylic Paints

Watercolors

Watercolors are made of finely ground pigments, mixed with gum arabic that acts as a binder, to which another substance, such as honey, is added to give it plasticity. It is also possible to add glycerin or ox gall to it. The glycerin improves the solubility and keeps the paint from cracking. The ox gall moistens the paint and helps it flow over the paper.

They are sold in the form of pans or tubes of different sizes, and can

Watercolor in Cakes

be purchased in boxes of assorted colors or individually. The prices are high, and the smaller the cakes the higher the price, since the quality of the pigment is better.

Their main characteristic is transparency. Mixing the pigment with water reduces the intensity of the colors and increases their transparency and luminosity. White does not exist in watercolors. When white is required, the paper can be left unpainted, or an opaque watercolor like white gouache is painted over the watercolors.

Because of their softness, sable hairbrushes are ideal for watercolors, although today synthetic brushes create similar effects and are less expensive. Washes can be applied with sponges, rollers, or paper towels. The ideal support is watercolor paper, which is available in different weights and textures. It can be worked dry or wet. In the latter case the paper must first be stretched on a board with adhesive paper tape.

Ink

Ink can be permanent or soluble in water. If it is not soluble in water, it contains lacquer, is denser, and has a glossy finish when dry. Water-soluble ink does not contain lacquer and is used for making line and hatched drawings with a nib or reed pen, and for washes applied with a brush. It has a matte finish when dry because it penetrates more deeply into the paper. It is available in different colors, although black is the most commonly used.

Ink can be diluted with tap or distilled water.

It is an ideal medium for mixing with other media to achieve very special effects. For example, colored ink and Quink (specially made for fountain pens) can be lightened with bleach, which creates some interesting effects.

When using inks, fine lines can be combined with washes. Quick and intuitive work is recommended, since the medium favors spontaneity and free expression.

It is best applied with round brushes because they hold more water. Drawing effects can be achieved using nib or reed pens. Pens are available with different nibs that can be used to draw fine or wide lines. The handcrafted reed pen is more primitive, and makes irregular and more expressive lines. Smooth or satin paper with a certain degree of durability is recommended as a support.

*These media are usually applied without a solvent.
They can be monochromatic or polychromatic.*

MONOCHROMATIC MEDIA

These are media of a single color, which are gradated to achieve an extensive range of values.

Vine Charcoal

These are made of sticks of grape-vine, beech, or willow, carbonized at high temperatures in an airtight oven. They are sold in boxes of several sticks approximately 6 inches (15 cm) in length and in different degrees of hardness and widths. The softest charcoal lends itself to rubbing and blending; the hardest is ideal for drawing lines and details. It is a very fragile medium, and it is recommended to draw with shorter pieces broken off the stick. Various gray tones can be achieved by wiping with a rag or the hand. Charcoal should be used with a textured paper. When a drawing is finished, it should always be protected with a final coat of lacquer or fixative.

Graphite Pencils

These are very thin sticks known as leads, whose degree of hardness is determined by the amount of hardener (clay) mixed with them when they are manufactured. A universal system was adopted for identifying the different hardness of pencils. The letter B is used for soft pencils, and H for the hard ones, preceded by a number or coefficient. Hard pencils range from 9H (the hardest) to H, and the soft ones from 9B (the softest) to B. The HB and F grades fall between H and B.

The soft pencils produce darker tones than the hard ones, making them ideal for shading and blending, and rendering expressive results.

The hard pencils are more suitable for technical drawings since they make precise lines and details and have a lighter tone. Generally, several grades of hardness are used in a drawing, to achieve a range of tones and expressiveness.

The universal support is paper; its weight, texture, and tone are chosen based on the desired effects. Normally, graphite can be used with

any type of paper, except waxed or very glossy papers. It is a good idea to apply a fixative or lacquer when the work is completed, especially if very soft pencils have been used.

Sanguine Crayon

This is a terra cotta-colored chalk made from hematite (an iron mineral) that has its own outstanding personality. A single color provides a full range of reddish tones. We can create excellent blended effects by rubbing with a rag or the fingers,

Sanguine Crayon

achieving softer and more luminous effects than those obtained with vine charcoal. Vigorous erasing will produce watercolor effects. Sanguine crayon can also be combined with other drawing techniques (pastels, vine charcoal, graphite). The most appropriate support for this medium is one that has a little texture or that is velvety. A fixative or lacquer should be applied when the work is finished.

Vine Charcoal

Graphite Pencils

Color Pencils

POLYCHROMATIC MEDIA

These media are normally used in combination with other colors, although they can also be used monochromatically, thanks to the large range of tones available.

Pastels

Pastels are made from pure pigment mixed with a base of chalk and bound with glue. They are mixed to form a stiff paste, which is then cut and molded into sticks, and left to dry until they harden.

There are hard pastels and soft pastels. The soft pastels have more pigment and less binder, which causes them to break easily. They create magnificent bright, saturated, and velvety tones that are ideal for rubbing and blending.

The hard pastels have less pigment and more binder. We can use hard pastels for making a preliminary drawing and for details and finishing. They are the perfect complement to soft pastels.

They are sold in boxes of assorted colors or individually. Prices can vary considerably. The high cost is due to the quality of the pigment; the more expensive it is the less chalk in the mixture and the purer its tone.

This is a very painterly and versatile medium, and it allows working with line, glazing, impasto, rubbing, and blending. The artist can work with the side of the stick, with the point, or with the powder that comes from the stick, spreading it with a brush, the fingers, or a cotton ball.

It should be used with supports that are rough or that have a heavy texture to hold the pigment, and on resistant papers that can stand up to blending, corrections, and creating effects with an eraser. When the work is finished, it should be preserved with a fixative or lacquer.

Color Pencils

These are made of pigments bound with kaolin and mixed with wax. Color pencils are easy to use and produce more immediate results. They are used the same way as graphite pencils, but their finish is less greasy, softer, and glossy. They are ideal for making small-format works. The quality of the pencils depends on the quantity and quality of the pigment. Higher-quality pencils have better covering power. It is possible to achieve different intensities by varying the pressure applied with the pencil. Colors can also be mixed, by applying one tone over another using hatch lines. Some color pencils are water soluble and their lines can be diluted with water. Paper is the ideal support.

Pastel Sticks

SUPPORTS

Wood

Wood is suitable for almost any media. It must be prepared according to the medium that is to be used. First the wood is selected, making sure it is dried and cured, with no resin, knots, or nails. It is best if it is not too well sanded. Then it is prepared, neither too much nor too little, as either extreme will make the adhesion of the paint to the support difficult, and the final result will be fragile and difficult to conserve. The porosity of the wood should be controlled with the appropriate product. Various materials such as gesso, casein, rabbit skin glue, latex, or latex diluted with water can be used, depending on the painting technique we intend to use. Both sides must be prepared so that the board will not warp.

Canvas
Panels

Boards and Canvas Panels

These are made with a cotton fabric primed with acrylic and mounted on a rigid support. They come in a range of standard sizes and in several textures. They are light and easy to transport.

Canvas

The canvases that are traditionally used for painting are made of vegetable fibers such as linen, hemp, jute, or cotton. They must be prepared to reduce their absorbency, but not so excessively that they lose flexibility, because a heavy preparation would cause the paint to crack. They are prepared with a primer. Primed canvas is available in rolls by the yard, or mounted on stretchers of various kinds, sizes, and formats. The sizes of the stretchers are international, each number corresponding to a specific length and width.

Paper

Paper is made of intertwined vegetable fibers, the most common nowadays being cellulose. The best is made with cotton, after which comes eucalyptus or pine (Kraft paper), which have woody fibers that deteriorate more easily over time. Papers that are ideal for wet and dry techniques are manufactured commercially and are available under a wide variety of brand names.

Papers

Preparing
a Board

Canvas

APPLICATORS

Nib Pens

Cotton

Brush

Brushes are composed of three parts: the hair, the ferrule, and the handle. They are available in several shapes and sizes. The choice of brush will be determined by the medium that is being used.

There are brushes with fine hair and stiff hair, and each group includes flat, round, and other shapes (filberts, brights, fan blenders, etc.). Each group has different sizes indicated by numbers. The types of hair used to make the fine brushes are sable, ox, otter, squirrel…

Stiff brushes are made with hog or boar bristles. Nowadays there are also brushes made with synthetic fibers.

Round brushes are usually made of fine hair and are most suitable for water-base media since they hold water better. The best-quality round brushes end in a point. Flat brushes usually have stiff hair and are most appropriate for oil-base media.

Nib Pen

This type of pen consists of a plastic handle and interchangeable steel nibs. It is an inexpensive drawing tool. Each steel nib makes a wider or narrower line according to its shape. The lines are even since the nib always dispenses the same quantity of ink. They are ideal for making details and hatching.

Reed Pen

We recommend having small pieces of sponge that can be held in the hand, to ensure more precision and control. Sponges can be hard or soft. The hard ones produce textured surfaces; the soft ones create smooth and even surfaces.

Cotton

Cotton is very useful for blending dry media, creating soft and airy effects. It can also be used to create areas of color when moistened with ink. Used dry, with acrylic or oil paint, cotton can make thick impastos. The cotton sticks to the paint and leaves pasty textures when pulled away.

Cotton Rag

Cotton rags are indispensable for any work. They can be used for erasing or blending a dry media, since they brush away the excess powder without damaging the support. A rag helps control excess water on the support and in the brushes when using wet media.

Brushes

Sponges

Spatula

This is an applicator in the shape of a knife or a palette knife. Spatulas are ideal for making impastos or for mixing colors.

Spatulas

Reed Pen

These pens are made of bamboo or reed and are very simple tools that can be made by the artist. Reed pens make irregular lines of varying width.

Sponge

Sponges are ideal for making washes and for glazing with water-base media. We can add or remove paint with a sponge, as well as wet paper, before using it.

Erasers

Eraser

An eraser is not only used for removing pigment, but is also an excellent applicator. It cleans up colors, creates light and shadows, blends tones, and reinforces the lines made with wax crayons. We recommend soft rubber or plastic erasers for linear and heavy-duty work, and kneaded erasers, which are softer and easy to control, for light and atmospheric results.

Techniques

A technique is the way a medium is used or a material is manipulated to achieve a specific plastic effect, although the term "technique" has commonly been used as a synonym for medium.

Transfer

This means moving a printed image to a support. The image that we wish to transfer is placed in contact with the support, rubbing the back of the image with cotton moistened with solvent. After letting it dry the photocopy is carefully removed, making sure that the image has been transferred to the chosen support.

Impasto

This is the application of large amounts of thick paint with a spatula or a stiff brush, imparting a certain amount of relief to the surface of the paint.

Blending

Blending is mixing paint directly on the support, taking advantage of the fact that the paint is still wet.

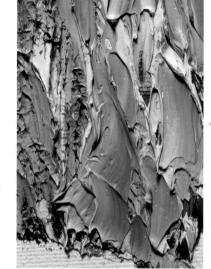

Impasto

Transfer

Blending

Flat Wash

A flat wash completely covers a surface with a color that is usually very transparent. It is applied to the surface by immersion, or with a sponge, cotton, palette knife, or other applicator.

Rubbing

Rubbing is the action of smoothing a color until its edges blend with the background or with another adjoining color, making sure that no traces of the applicator are left visible.

Flat Wash

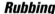

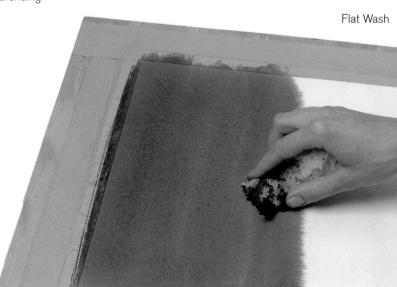

Rubbing

Scraping

Glazing
Totally or partially applying a transparent or semitransparent color over another color to vary its tone or value.

Glazing

Dripping
This is a painting effect produced by letting paint fall onto the support from a certain distance with more or less force and in small quantities, causing it to disperse in the form of drops.

Wash
This is a painting technique where very diluted paint is applied to a support using wide applicators and without precise details.

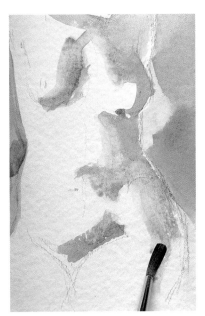

Wash

Scraping
Scraping means partially eliminating a layer of paint using blades or needles to cause the background or a previous layer of color to emerge.

Scumbling

Scumbling
This effect is achieved by scrubbing paint that is still wet with a brush, rag, or other applicator, dragging and partially eliminating the paint, leaving part of the background visible.

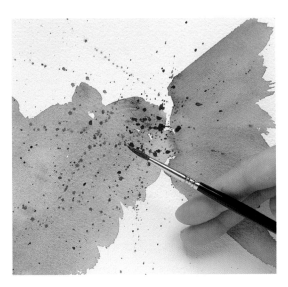

Dripping

Collage

Collage
A collage is an image formed by gluing pieces of paper, fabric remnants, wood, sand, cardboard, or other materials to a support.

FO